For his 98th birthday, friends at LIFE Books put him on the magazine cover.

Wishing you the happiest of birthdays from all your friends at LIFE

Joyeux Anniversaire,
Paulan

Have a lovely birthday!
Roslani

Happy Happy Birthday David! I hope it's wonderful!
Sarah

Dear David —
much love to you on your birthday!
Christina

Happy Birthday, David.
Regards,
Ben Cosgrove

With our love always
Bobbi & Russell

BBB

love John Crane

Happy Birthday David!
—Courtney

98 More!!
xxx's + ooo's,
David Friend

LIFE
DAVID DOUGLAS DUNCAN
JANUARY 23, 1946 10 CENTS

Dear David
Felici tations!
Love from LIFE and
Bob Sullivan

Happy Birthday dear David with all best wishes
Ann Morrell

Happy Birthday

Looking forward to your work over the next 98 years!
Jay Bomba

23 January 2014

Kodak - Graflex - Rolleiflex

Leica with 1950 Nikon Lens/Korea M3D Leicas for Picasso and War

Nikon S620 Coolpix

ARCADE PUBLISHING • NEW YORK

My 20ᵗʰ Century

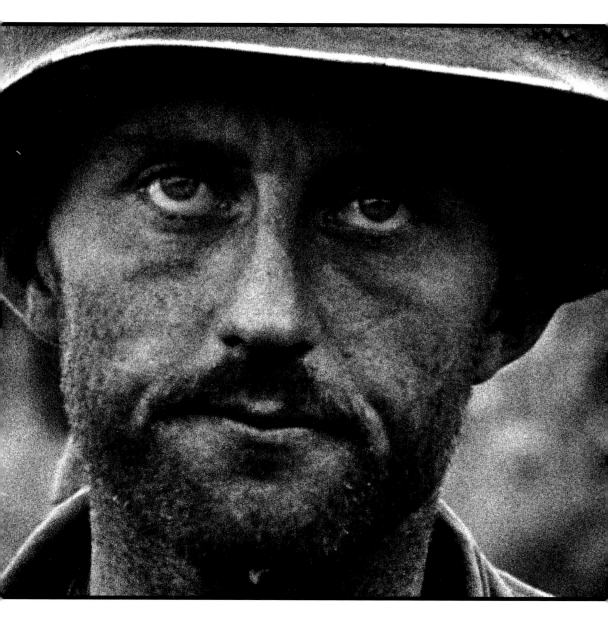

David Douglas Duncan

Manuscript computer composition by Franck Follet, Antibes, France
Digital master prints by Jef Regnier, Mougins, France
Photography, text, design, production by David Douglas Duncan

Arcade Publishing® is a registered trademark of Skyhorse Publishing, Inc.®,
a Delaware corporation.
Visit our website at www.arcadepub.com.

10 9 8 7 6 5 4 3 2 1

Library of Congress Cataloging-in-Publication Data is available on file.

ISBN: 978-1-62872-561-2

Printed and bound in Verona, Italy

Dreams and Memories

30
Nights and Days
of
One Life
in
One Room

Preface

Duzi was barely a handful, three months old, when he first saw his new home on a hilltop on the south coast of France. After leaving his little brother and sister in central Provence he slept most of the trip curled on my chest. Another Norwich, Yo-Yo, dominated our lives for fourteen years. Once ransomed from a gang of Marseille Gypsy car thieves. Also three months old. Yo was my wife Sheila's shadow until that long last night, then "Goodbye."

I began documenting Duzi's life when he was one week old with Nikon's S620 Coolpix amateur camera. By accident. My fax machine collapsed, replaced by one too gadgety bought with a bank card. The salesman said refunds took "forever" so maybe find something else. A nearby shelf held digitals, which I'd never shot in my life. I chose the Coolpix. In Tokyo, May 1950, I'd adapted Nikon-Nikkor lenses for my Pacific War-dented Leica.

One month later, as a LIFE photographer, I was photographing the Korean War.

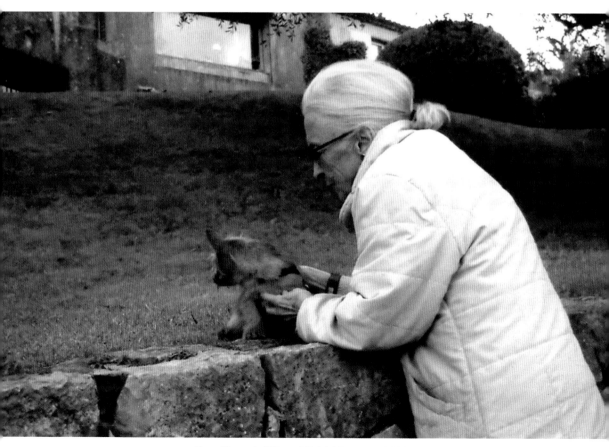

Castellaras le Vieux 53 / 14 January 2009

"Welcome Home Duzi!"

The New York Times published a story about an unknown Japanese lens on a Leica. Six years later in Germany, friends at Leica never mentioned Nikon or Korea while creating four M3D super-silent Leicas for me to then photograph Pablo Picasso; years later, unfailing on battelfields of Vietnam.*

After test-shooting in the new digital world I aimed at Duzi. Pictures shot under almost impossible conditions with oldtime Kodachrome or even high speed black-and-white film. Unreal for me! Familiar to every novice, photographing their world today with smartphones.

One year later — midnight — Duzi pretending to be asleep when carried to his bed while snuggling against my chest, I tripped on a lamp cord. Slammed into the floor. He was unhurt. Licked my face and hands.

Rolled over onto my back — fractured right hip.

*Those voiceless 1956 Leicas cost $375 apiece. Several years ago I sold M3D2 to another former Marine from Vietnam working in Singapore. In Vienna, 24 November 2012, it was sold at auction to a collector of vintage cameras from Hong Kong for $2,180,000.

"No Pain?"

Sheila heard the crash, brushed Duzi aside while helping me into bathrobe, agreeing it was ridiculous hour to phone the emergency number known everywhere in France. Our friend Dr. Paul Charbit arrived at nine, hand on my thigh: "Don't move! Ambulance coming, X-ray room waiting. General checkup before noon. Room reserved. It's now Friday. Operation will be midday Monday. You're going to Clinic St. Basile just down the road. Still no pain? That's strange. *Ciao!*" . . . out the door answering his cell phone.

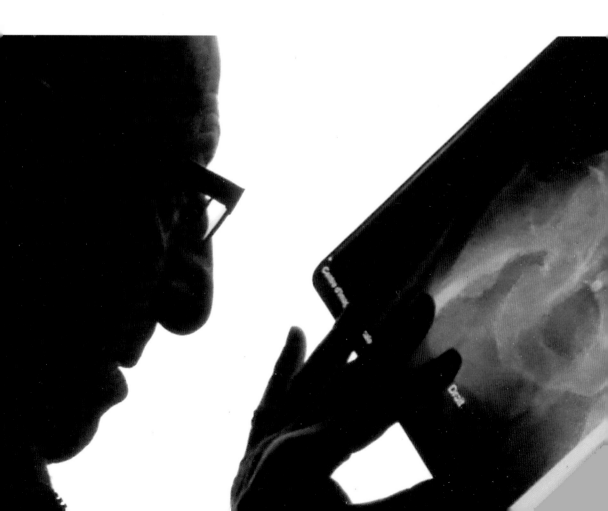

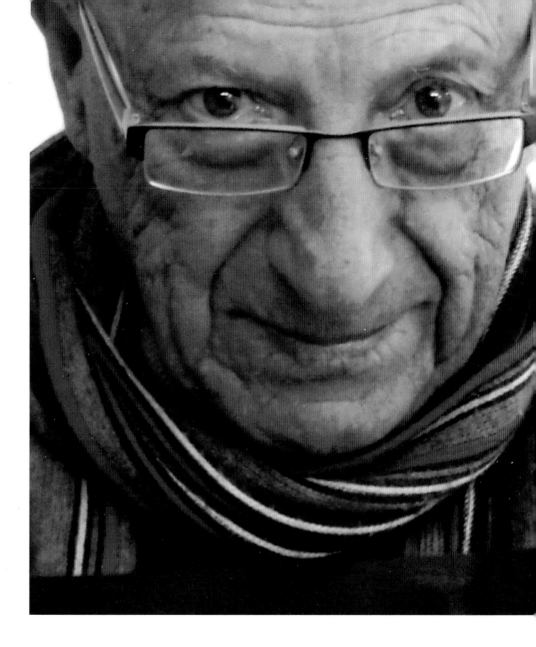

Tuesday, mid-morning: Paul Charbit was examining my hip X-ray at the hospital window while I started shooting my new digital miniature camera — comfortably flat on my back.

Silence as the film rotated in his hands. Then that half-smile.

"There is a problem. You will be here one month — you almost broke your spine."

Looking into those eyes I was back in my own world.

Thirty nights of dreams and memories.

Marines advance into enemy fire
first enemy casualty of Korean War

Marines Captain Ike Fenton
first US assault Naktong River Perimeter
raining lost radio contact with battalion
enemy attacking men falling no ammo just grenades

August South Korea 1950

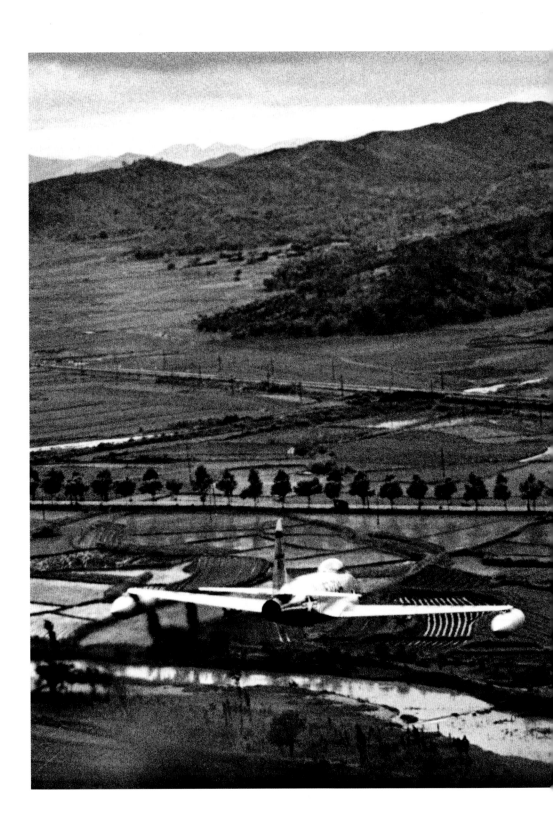

Shooting Star jet by Lockheed attacks North Korean lead tank
near Suwon South Korea with cannon fire before rockets while
I shot from front cockpit of a special jet piloted by Air Force
Lt. Colonel Bill Samways commanding all other jets over
that monsoon soaked land where I was convulsed by crushing
physical pain unknown ever before as Samways dived and
then yanked that jet into an almost vertical skyward blast
then again dived toward a tank in the column churning south
and I kept shooting the first photographs of jets in warfare

South Korea 14 July 1950

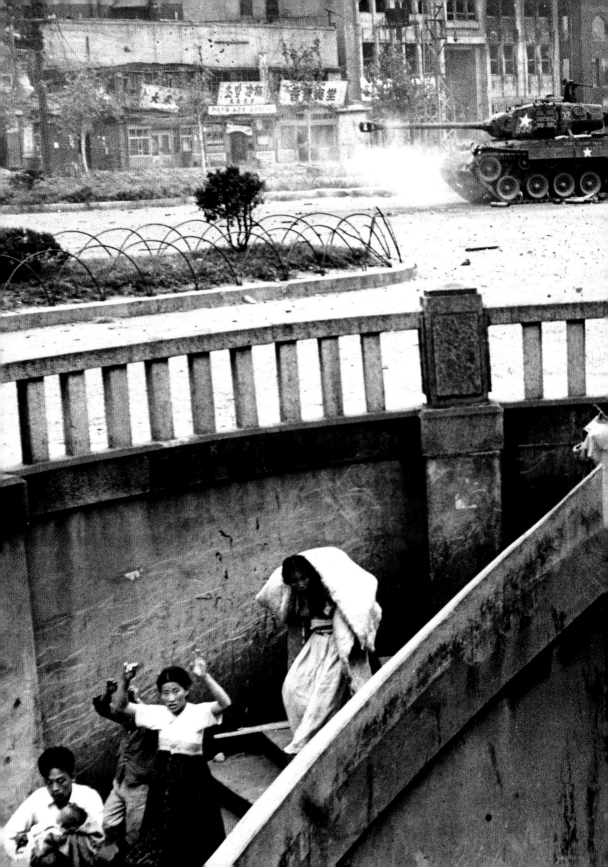

US Sherman tanks exchange fire with North Korean gunners
shooting from buildings in center of the city

Sanctuary!

Central Station
Seoul South Korea 25 September 1950

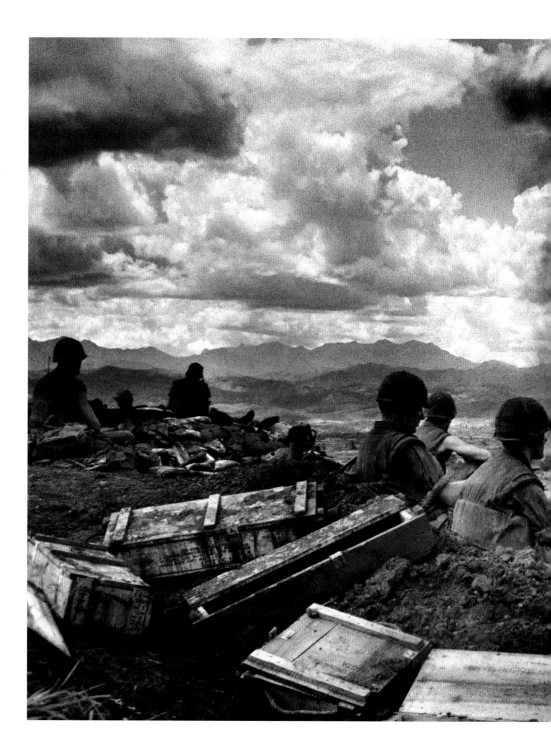

Marines holding hilltop facing enemy bombed nightly by B52s from Guam

Con Thien Vietnam September 1967

Sniper team atop hill 861 Alpha
Marines Albert Miranda David Burdwell Alec Bodenweiser

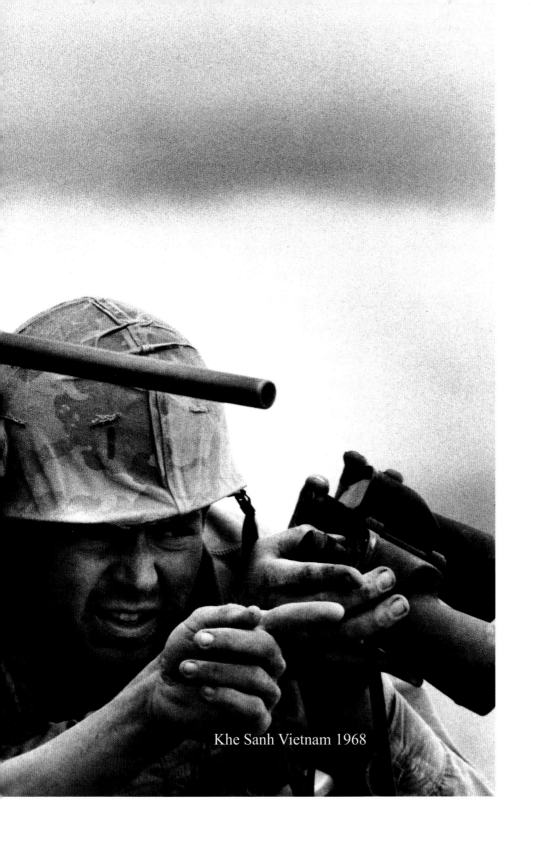

Khe Sanh Vietnam 1968

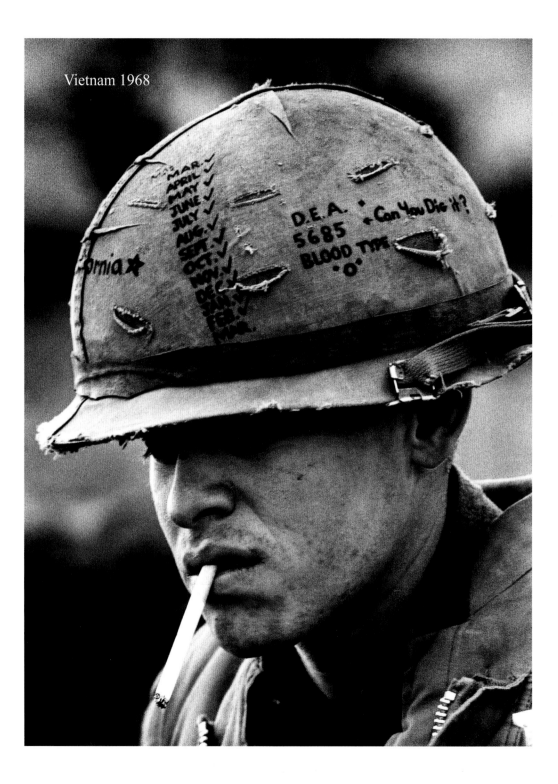

Vietnam 1968

Manchurian border Siberian wind 40 below zero
Chinese everywhere
North Korea December 1950

Goodbye for Today!
Christmastime
North Korea 1950

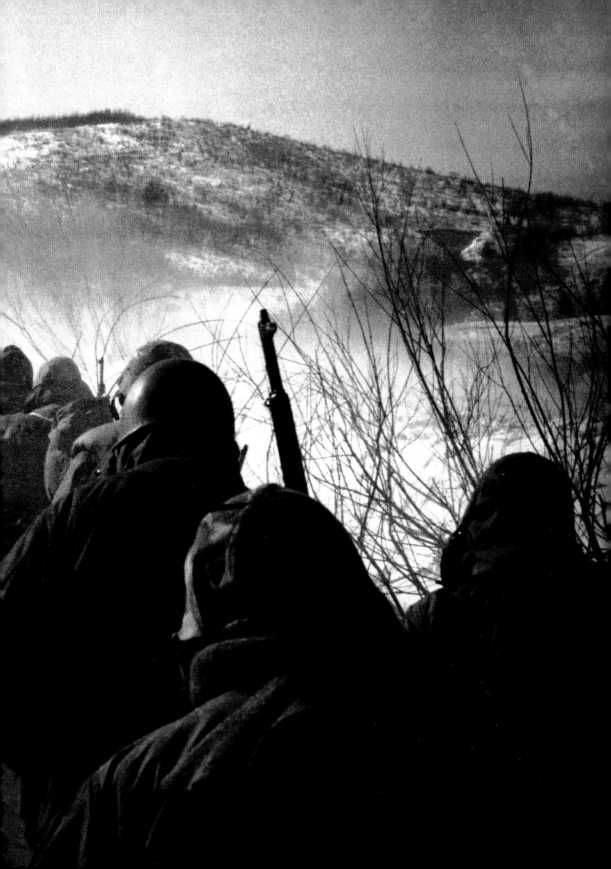

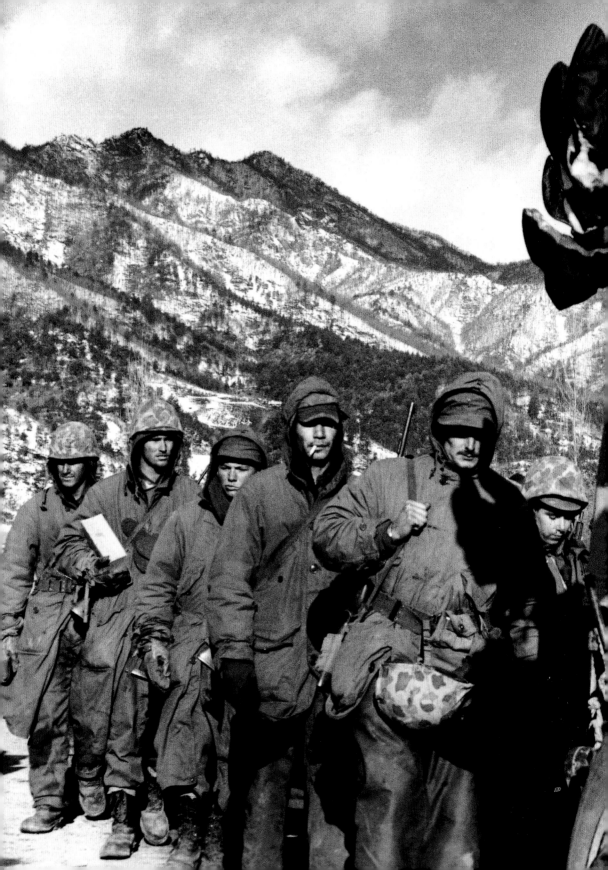

Goodbye Forever
North Korea 1950

8th February 1968
Khe Sanh Marines going home
My last photograph in Vietnam

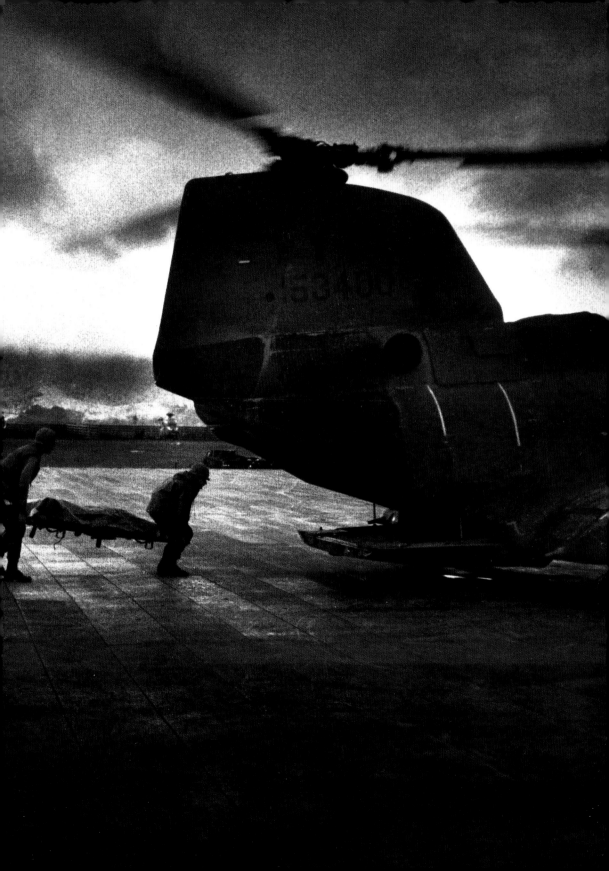

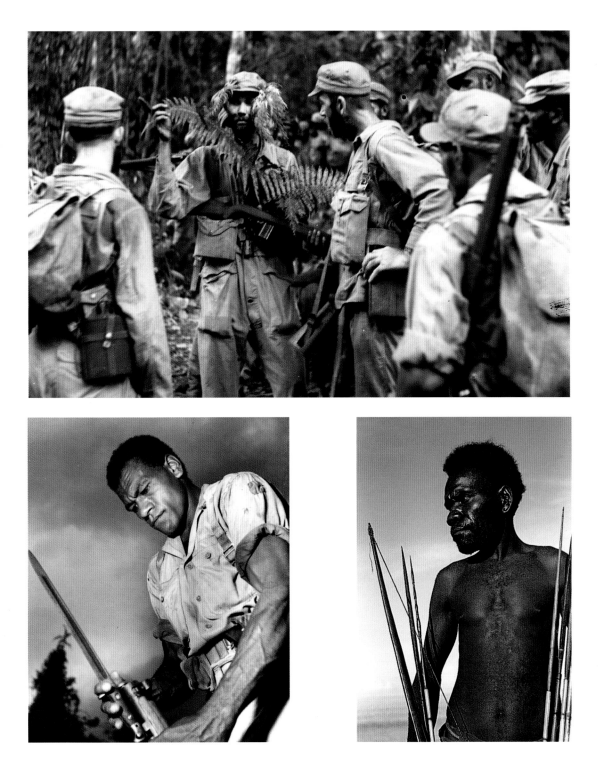

Fijian Guerrillas Bougainville Solomon Islands 1944

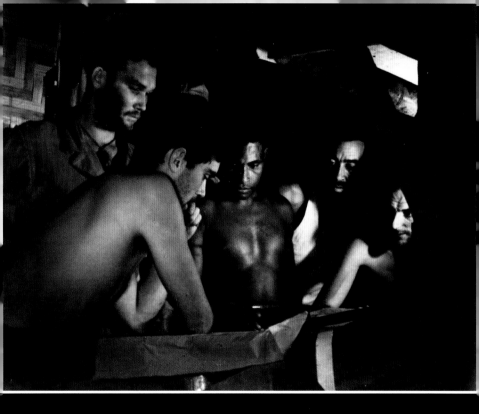

New Zealand officers every man had malaria
Bero a Papuan New Guinea killer-scout
normally prowled their jungle perimeter alone

Fijian guerrillas neighbor
Bougainville village chief 1944

Tortured Shepherd
Greek Civil War 1949

Suspicious Shepherd
Patzcuaro Mexico
Autum 1942

34

Monument of Antiquity
Great Pyramid of Chichen Itza
Yucatán Mexico 1939

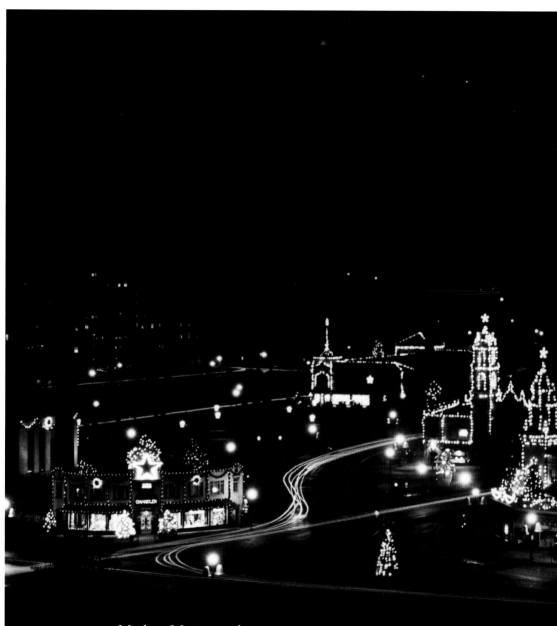

Modern Masterwork
Thanksgiving to New Year
My Hometown Country Club Plaza

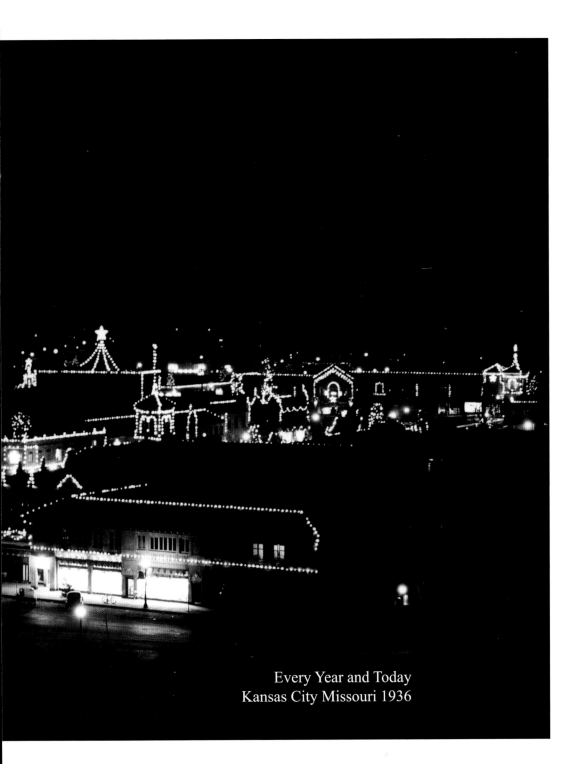

Every Year and Today
Kansas City Missouri 1936

Château behind our home
Castellaras le Vieux France

Copilot
to
visit
Neighbor Picasso

Villa
La Californie
Cannes France

Lump von Bachguatel
4 March 1956
Stuttgart Germany

Mercedes 300SL
4 April 1956
Sindelfingen Germany

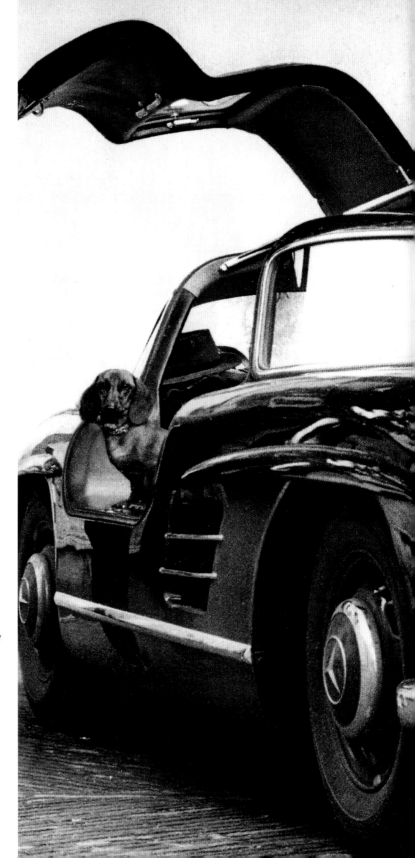

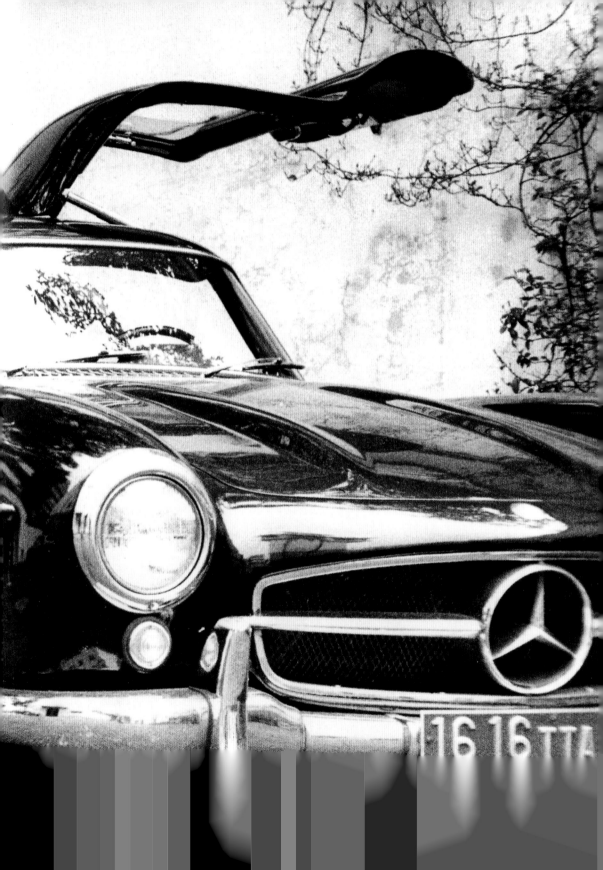

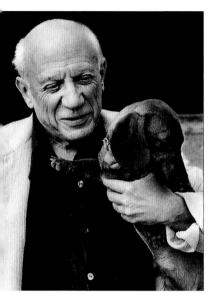

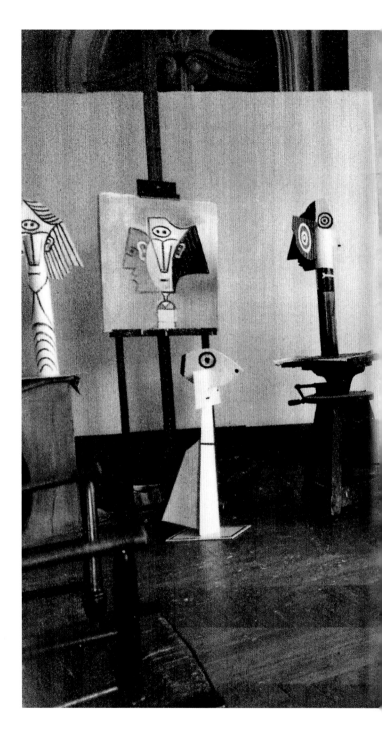

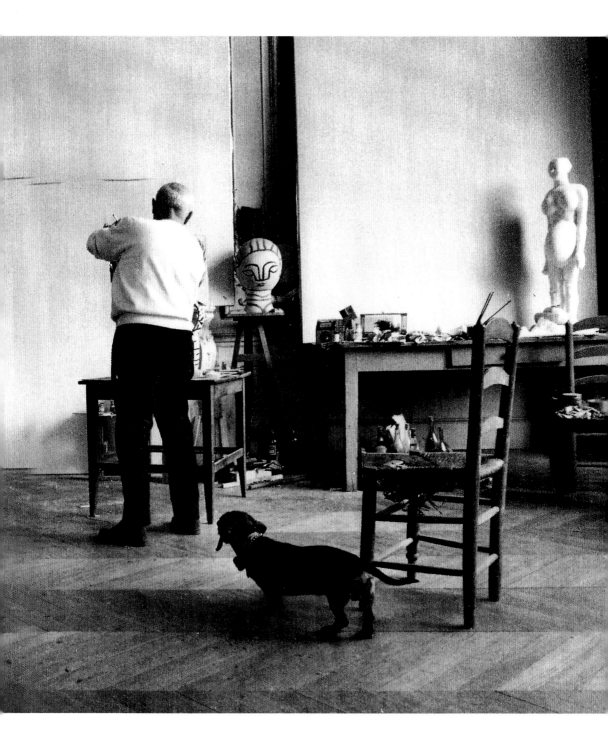

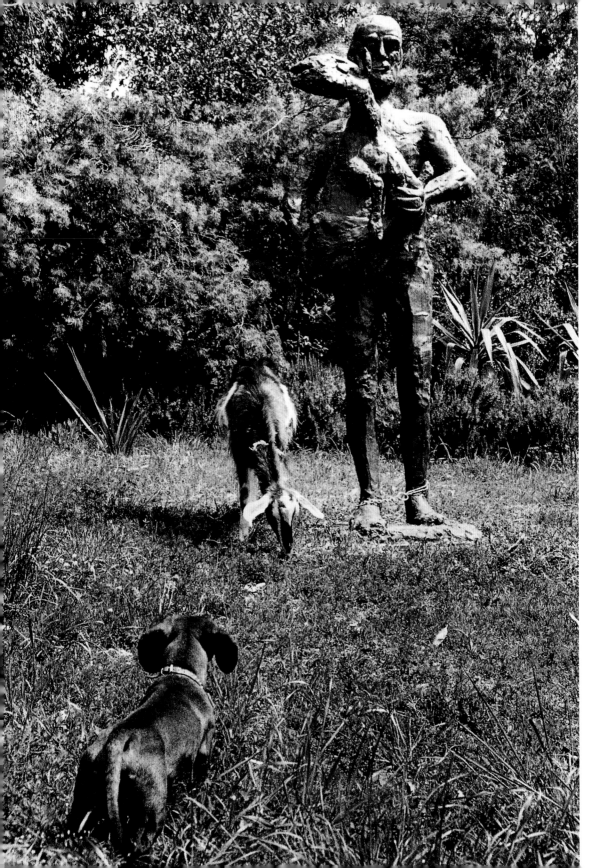

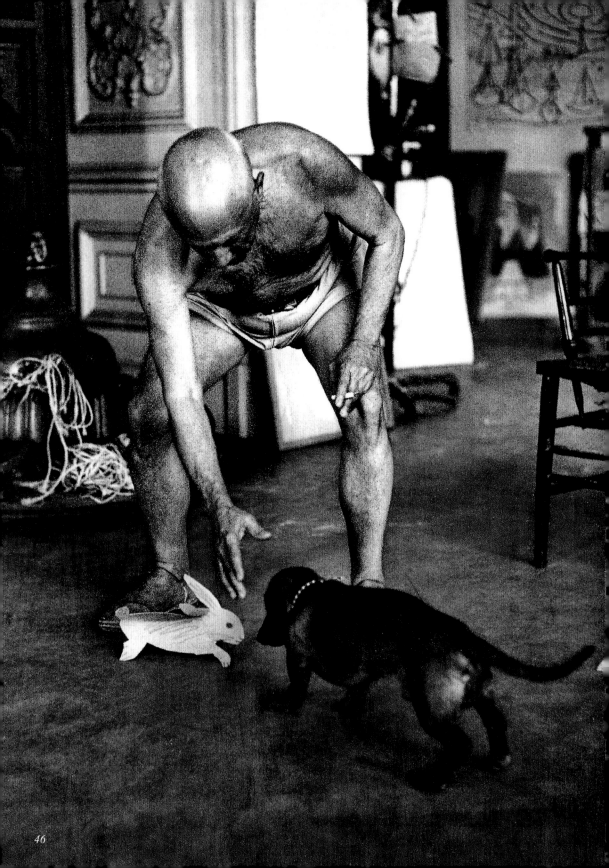

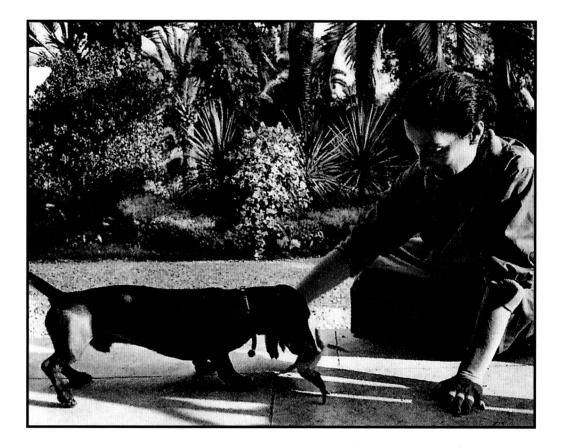

"Has Lump ever seen a rabbit?"
"No!"
So he made one
Lump attacked then took it out to Jacqueline
Where he ate it

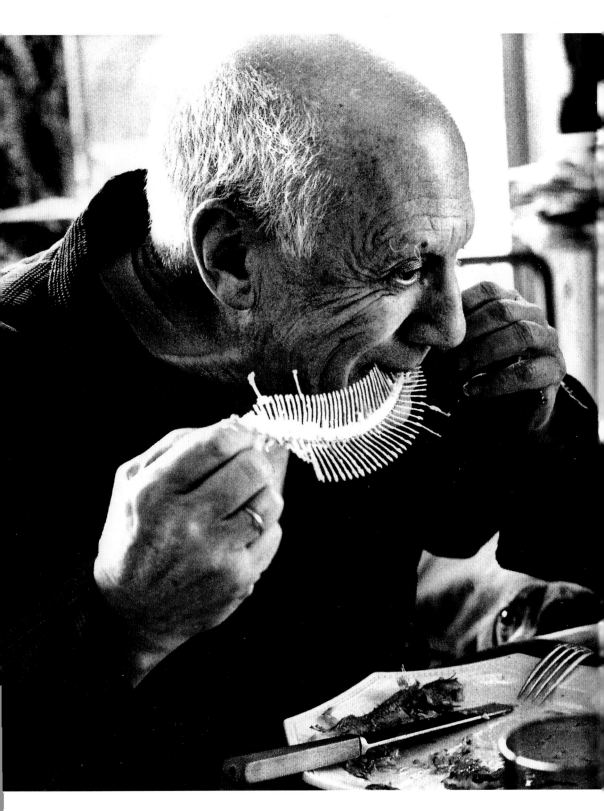

Picasso played the fish skeleton
like his Spanish harmonica
I had never seen anything
like that before

Nor had Lump!

"Does Lump have his own dinner plate?"
"No"
"Tell him to wait a few minutes"

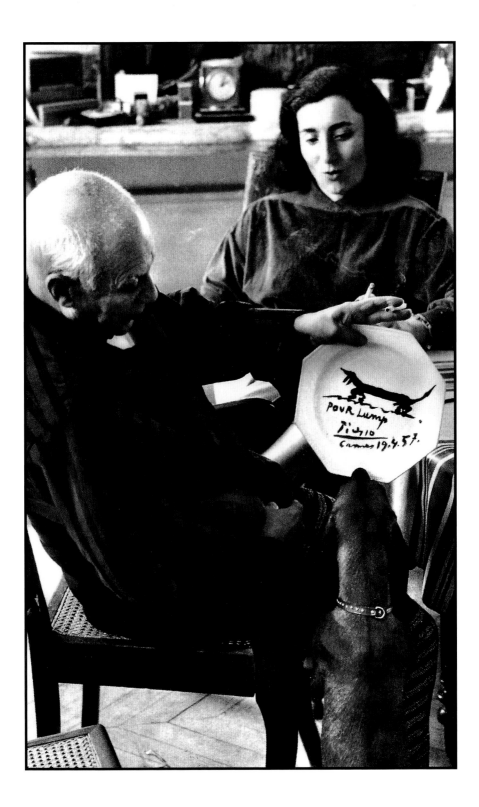

POUR Lump
Picasso
Cannes 19.4.57.

Picasso
Lump
Velásquez

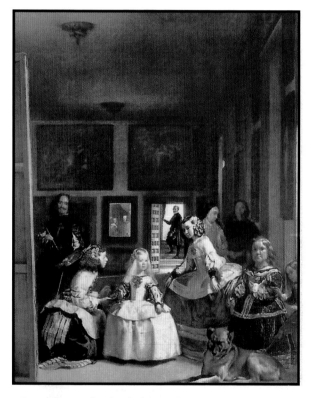

Lump now had a role in the history of Spain
an unprecedented odyssey from his
Stuttgart birthplace

There they were! Pablo Picasso's variation on Velásquez's *Las Meninas*
royal treasure in the Prado Museum of Madrid. Fiftyfour canvases including
nine of pigeons on the studio balcony (17 August to 30 December 1957)

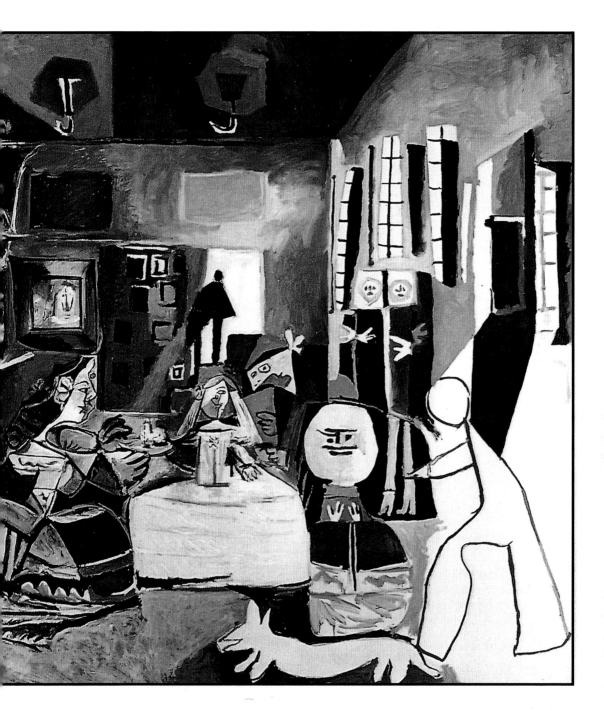

He had replaced the giant dog at the feet of Infanta Margarita with her
"Ladies-in-Waiting" — also Velásquez himself, court painter of King Philip IV
and his 17th-century Spanish Empire (Picasso Museum Barcelona)

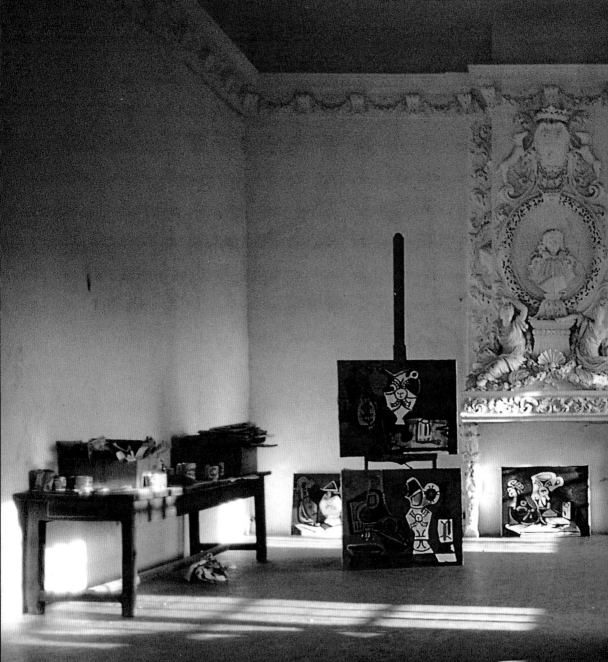

September
1962
Château de Vauvenargues

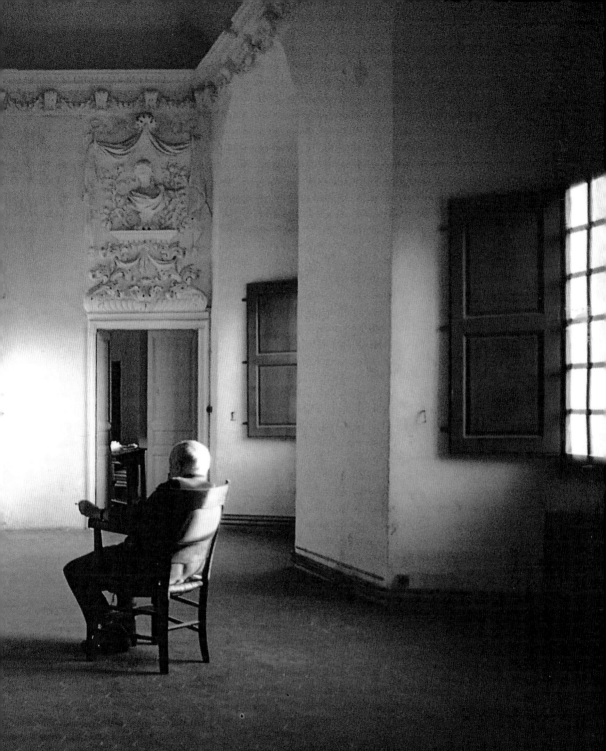

Eternity

Beyond the Window Beneath the Garden

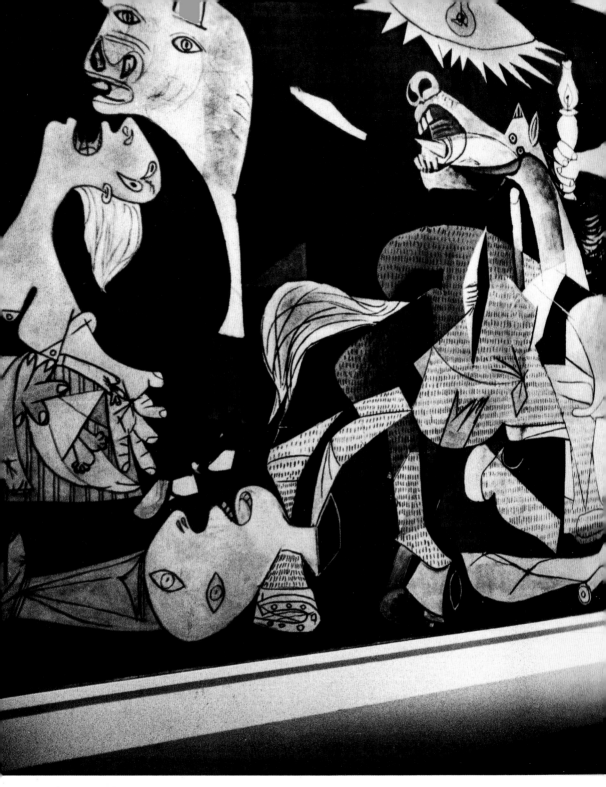

Museum of Modern Art New York
18 September 1982

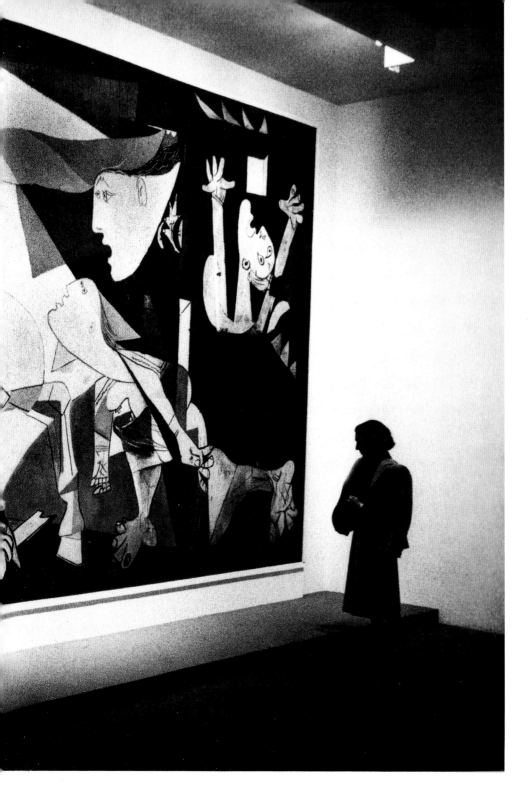

Jacqueline saw *Guernica* for the first time

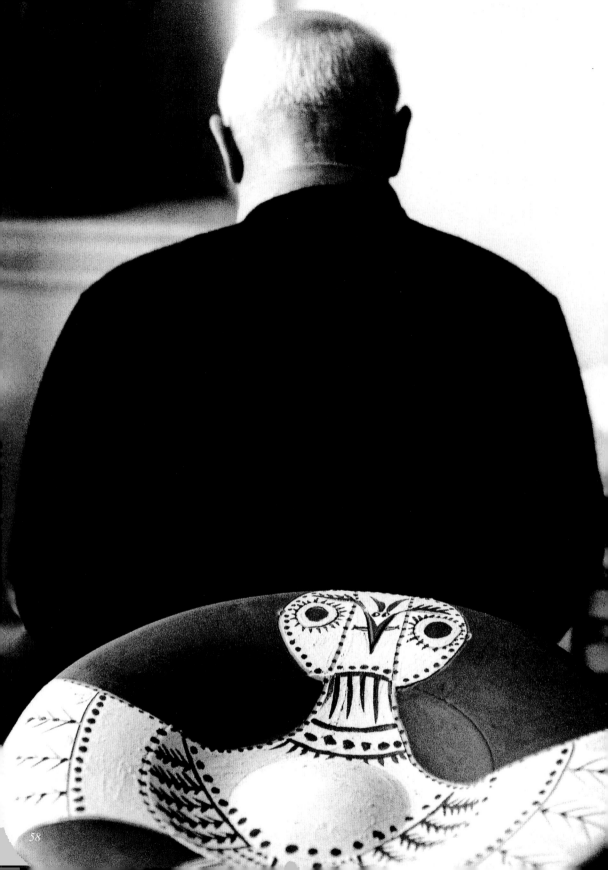

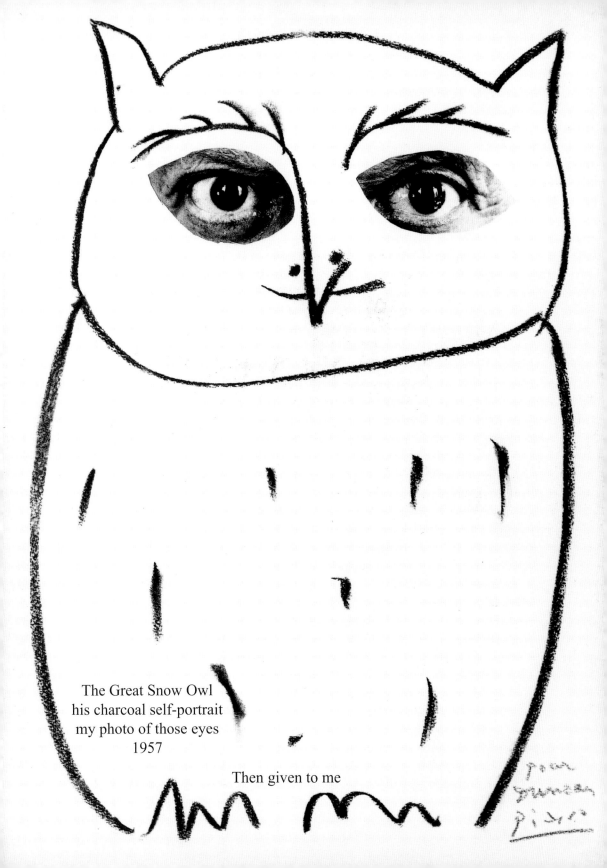

The Great Snow Owl
his charcoal self-portrait
my photo of those eyes
1957

Then given to me

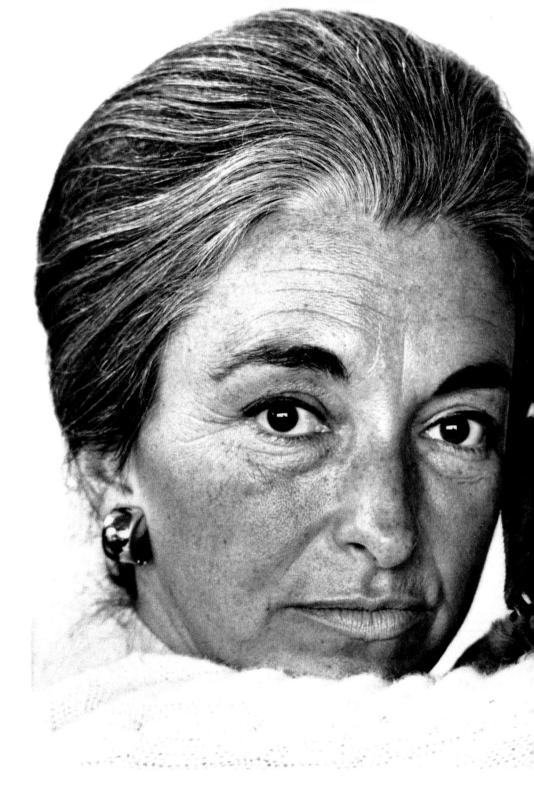

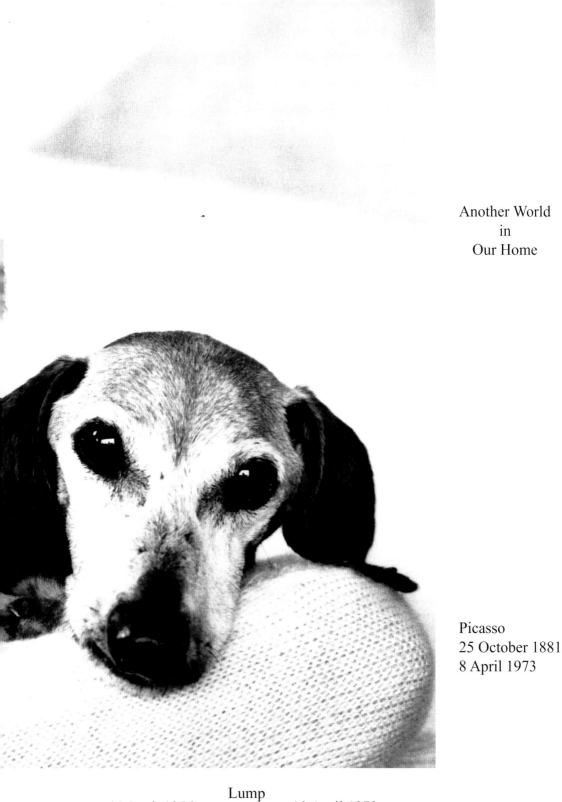

Another World
in
Our Home

Picasso
25 October 1881
8 April 1973

Lump
4 March 1956 10 April 1973

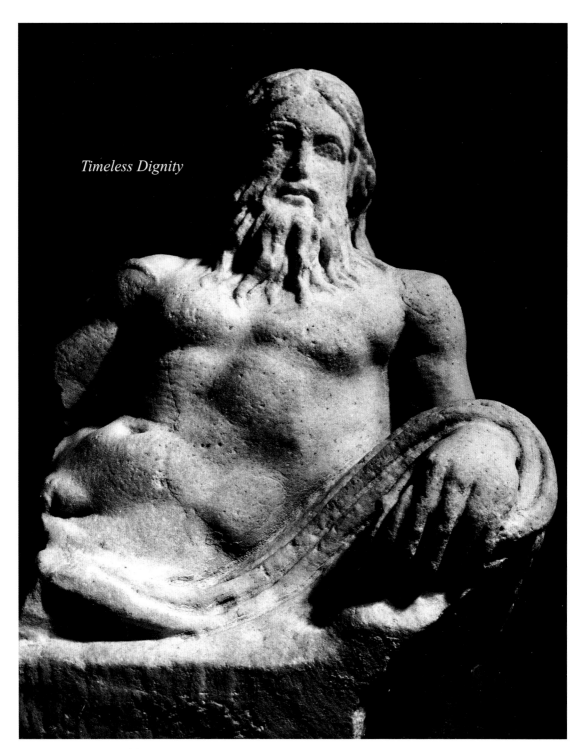

Timeless Dignity

Poseidon 1st-century A.D.
Found in Bosphorus Straits near Istanbul Turkey 1947

Grandmother Granddaughter
retirement home
Kansas City Missouri 1936

My first attempt beyond snapshots
with second-hand folding Kodak

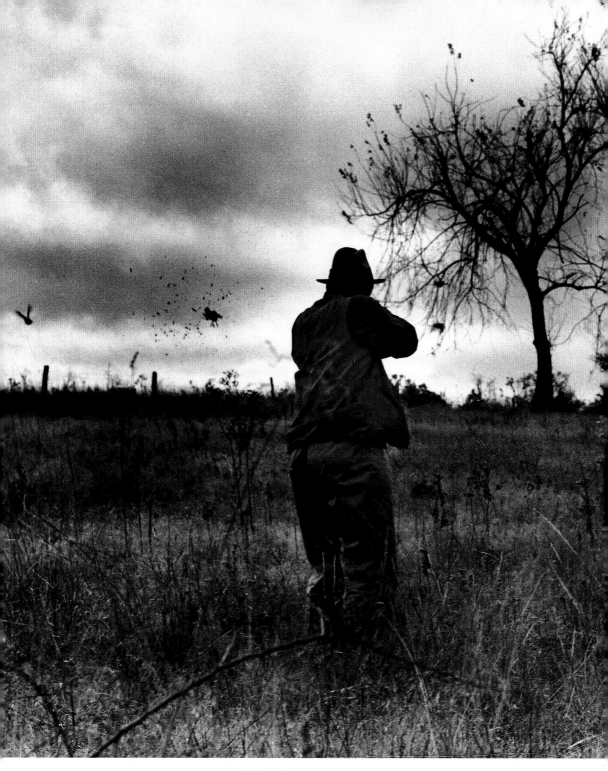

Quail hunting Missouri 1939
1/1000 second with Series D Graflex (page 102)
My first photograph sold to LIFE

The first "adventure" photo of my dream
of professional life as a Yankee nomad with cameras

Catching rattlesnake Florida 1935

Michael Lerner and Captain Doug Osborne
Lerner American Museum of Natural History Expedition

Broadbill Swordfish Cabo Blanco Peru 1939

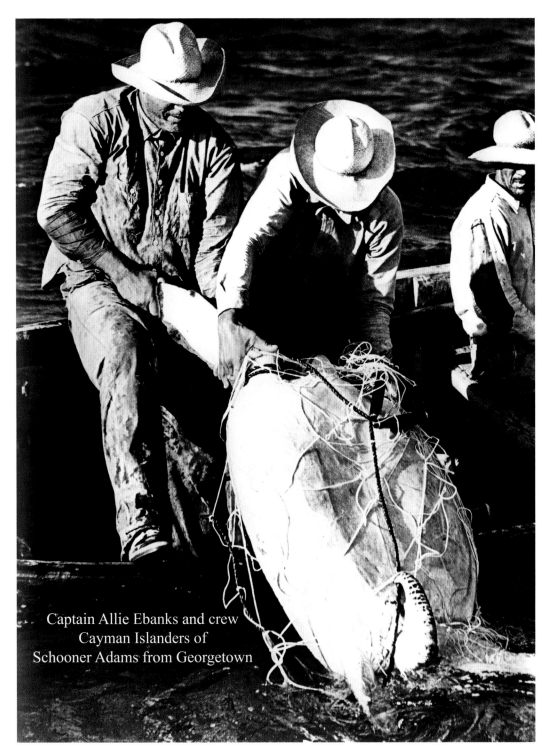

Captain Allie Ebanks and crew
Cayman Islanders of
Schooner Adams from Georgetown

Giant green turtle Miskito Coast Nicaragua 1938

Giant ink-squirting cannibalistic squid
first ever taken (midnight) on rod and reel

Lerner and Osborne with
goggles under pillowcases to protect eyes

Lerner Expedition Tocopilla Chile 1939

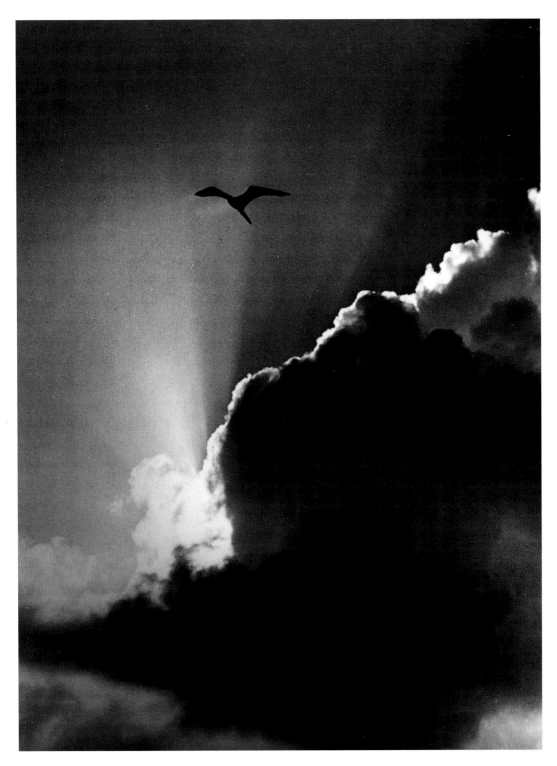

Frigate bird Cayman Islands 1938

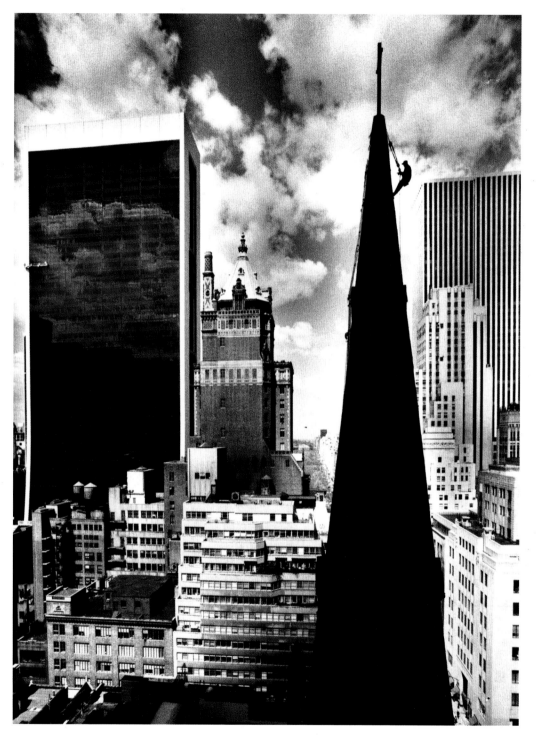

5th Avenue New York 1975 steeplejack atop Presbyterian church
on front page NY Times next morning thanks to Managing Editor
Clifton Daniels first met in Saigon during Indochina War of 1951

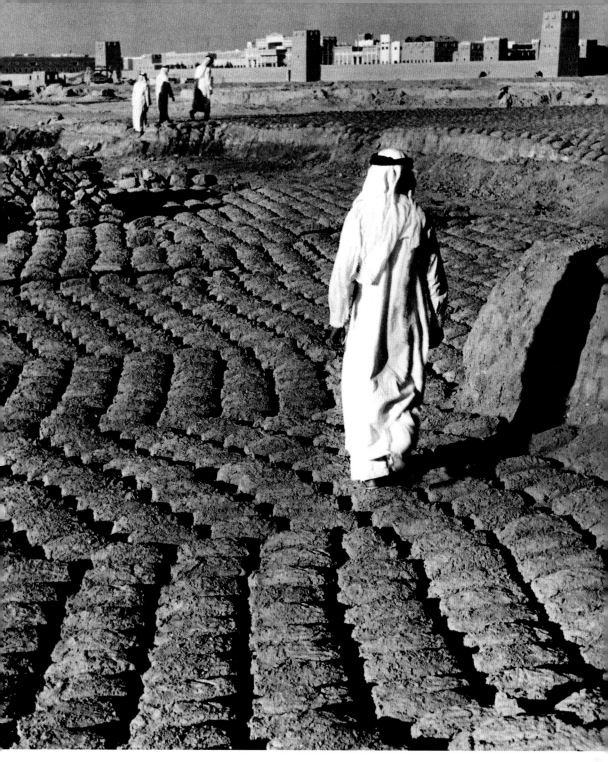

Adobe bricks hand labor protected a remote fortress city
closed to foreigners before oil boom
that changed their world and our's forever
Riyadh Saudi Arabia 1948

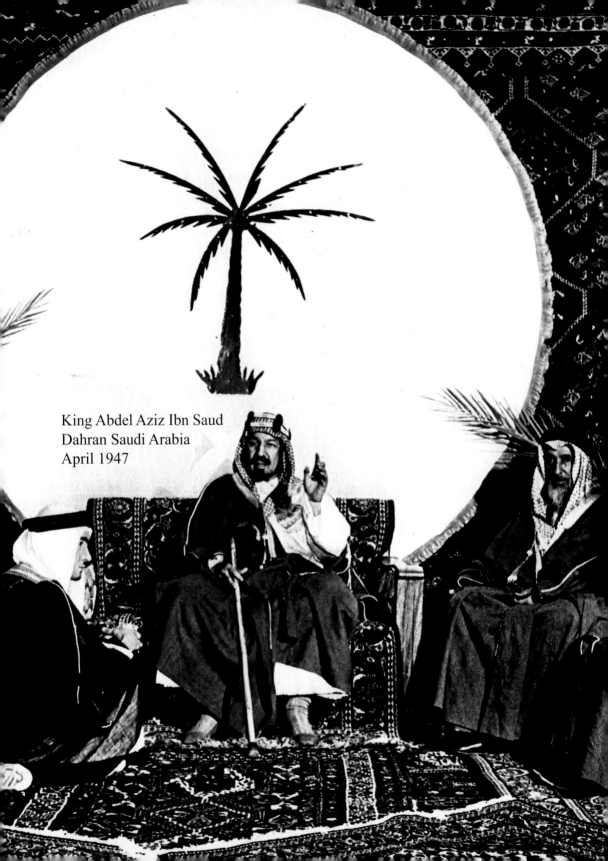

King Abdel Aziz Ibn Saud
Dahran Saudi Arabia
April 1947

Reconciliation
after
40 years of religious conflict

King Abdullah of Jordon
in white robes
direct descendent
of
Prophet Mohammed

King Ibn Saud of Saudi Arabia

Riyadh 1948

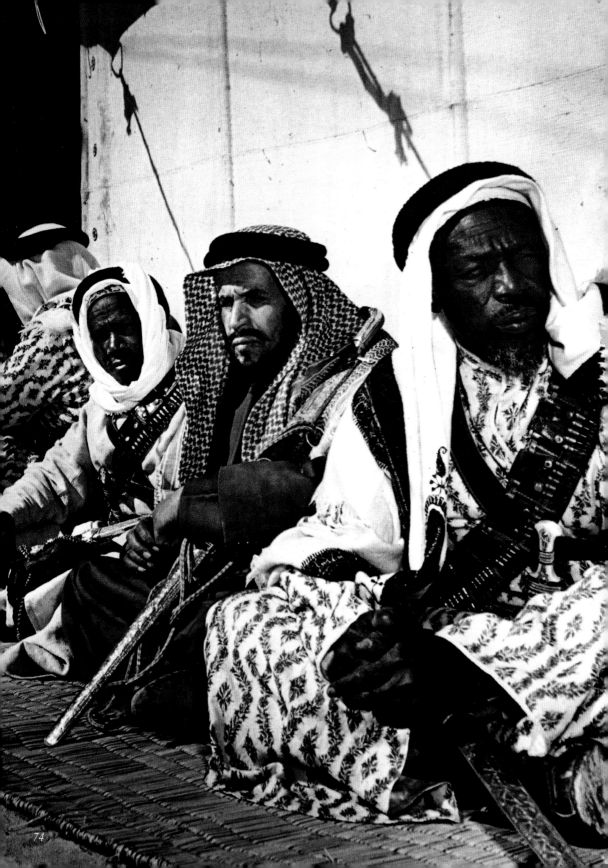

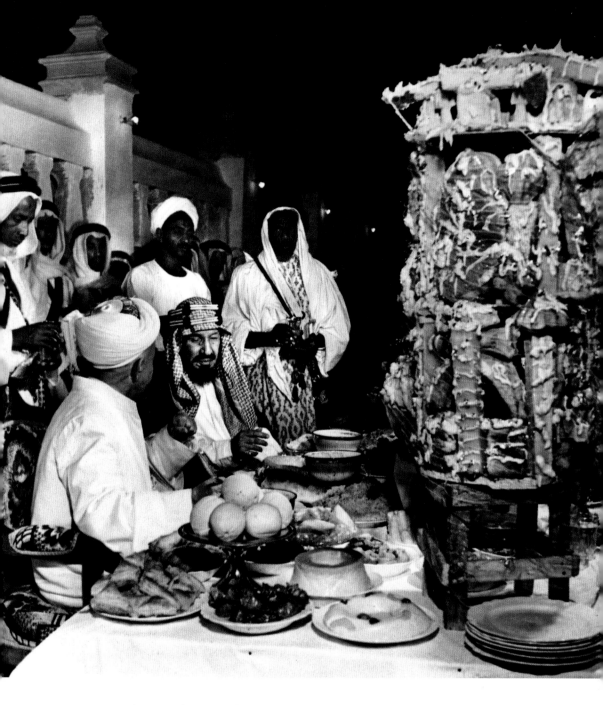

A palacetop banquet for kings
Abdullah and Ibn Saud

Bodyguards of Ibn Saud

Riyadh 1948

Abdullah pointed at me
"Who is *that*?"

Abdel Aziz Ibn Saud
"My friend"

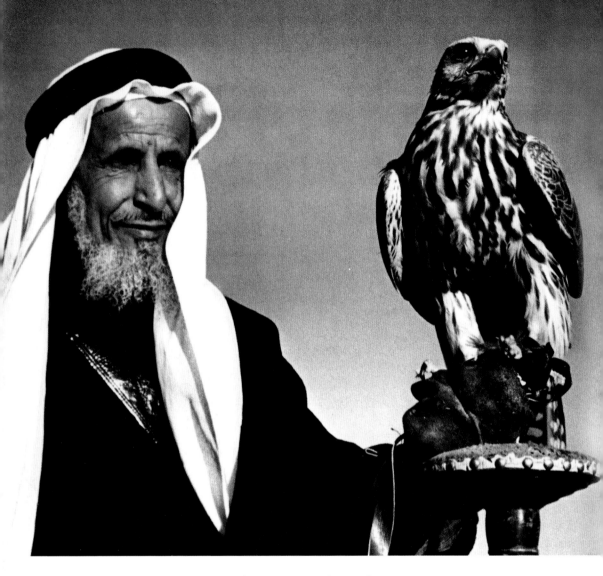

Falcon master of Royalty

Gentle Prince Faisel
Cambridge
Jeddah Saudi Arabia 1953

King after his older brother Saud abdicated
following death of their desert warrior father who
founded Wahhabi Kingdom of later religious fanatics
nineteen who crashed New York's Trade Center Towers
9/11 but before that one had stabbed Faisel
freeing the 7th-century Islamic demons of today's ruthless jihadists

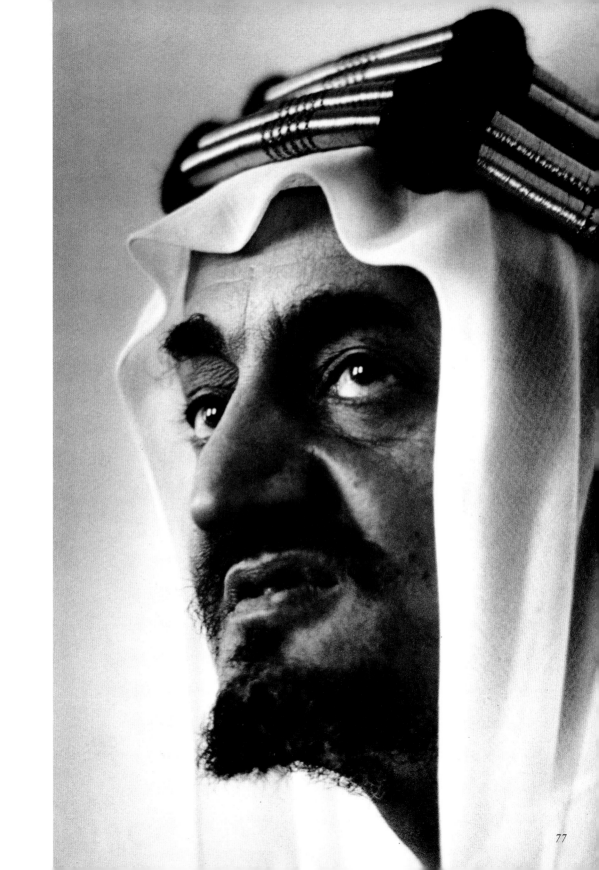

Skyline shepherds/camels/legendary Mecca
Arabian-American oil colossus
"Flaring" well Abqaik Saudi Arabia 1947

Geologists with cobalt glasses judge moment
when gas turns to pressurized petroleum then run

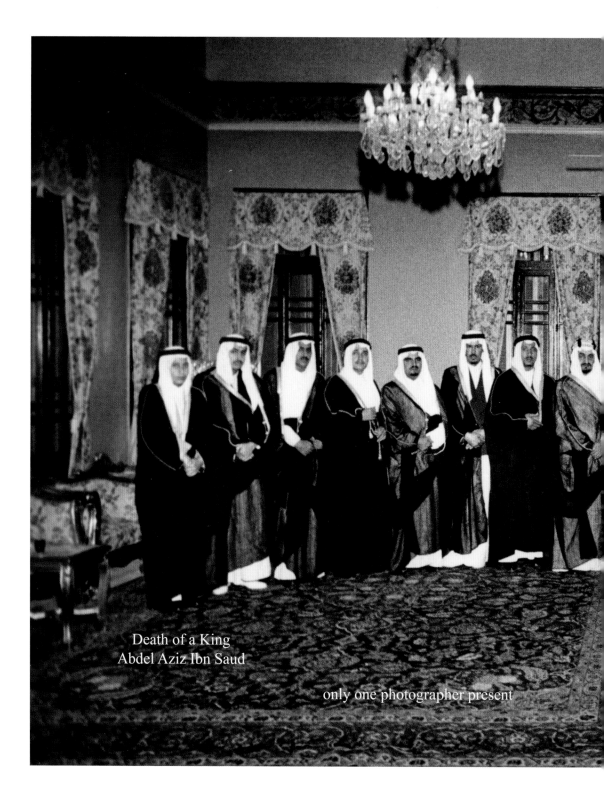

Death of a King
Abdel Aziz Ibn Saud

only one photographer present

18 brother Princes
Royal palace Jeddah 1953

not one princess of any age visible

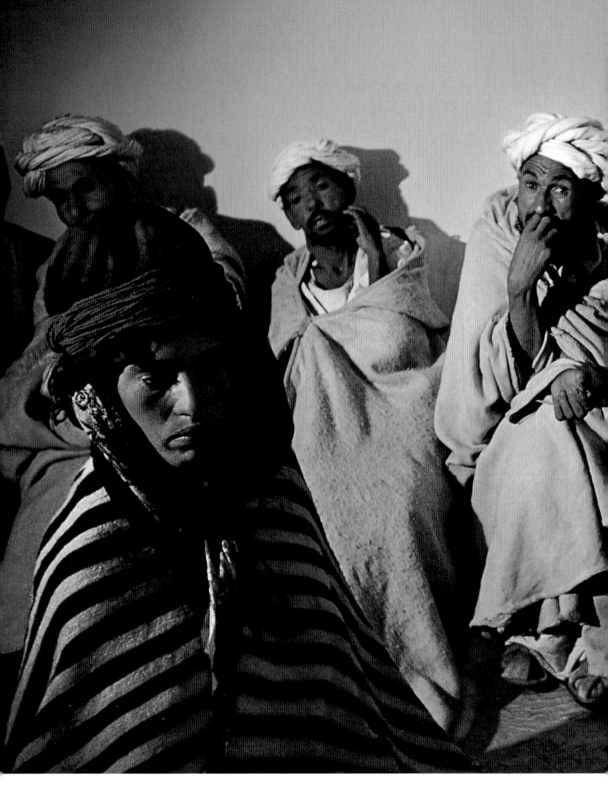

Trial by Village Elders
Adultery or Rape
"Innocent!"
Berbers of High Atlas Mountains
Morocco 1955

Old Moha
African potter for Berbers
Morocco 1955

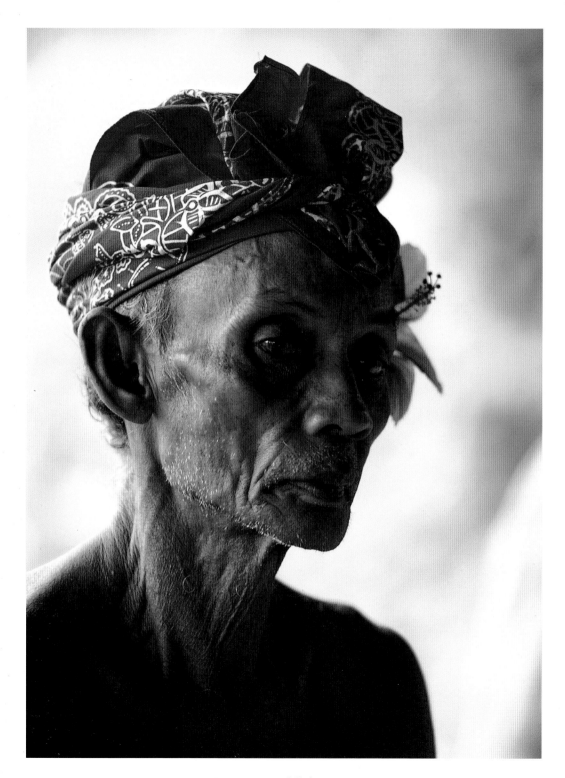

Veteran reef fisherman
Bali 1972

Chief Picasso
as
Blackfoot American Indian
gift
Gary Cooper 1960

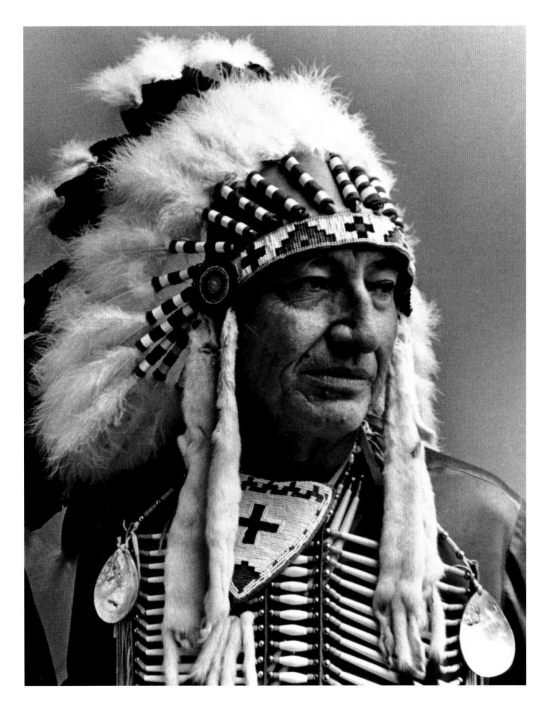

Chief Ben Stiffarm of Blackfoot tribe Montana
Seattle Washington 1983

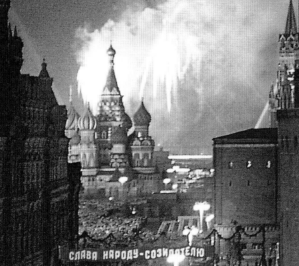

СЛАВА НАРОДУ-СОЗИДАТЕЛЮ

The Kremlin 7 November 1956 Red Square
Almost-War-Again Birthday Party for Mother Russia

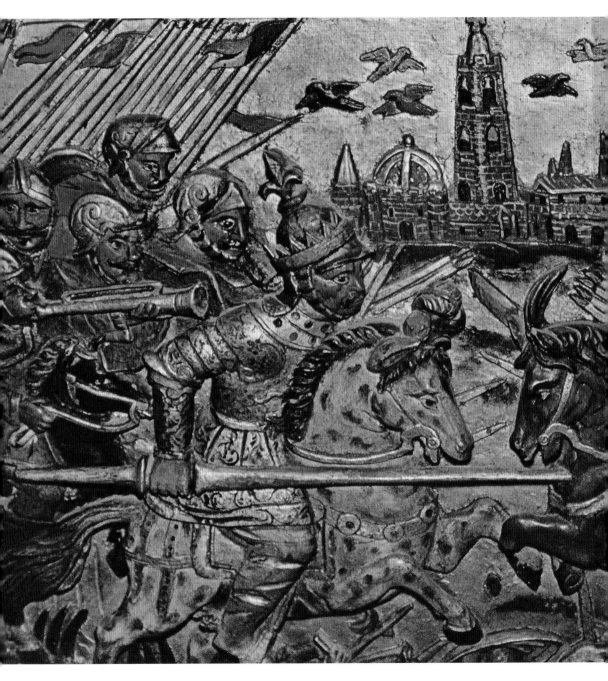

17th-century Russians repulse Turks Kremlin Museum 1958

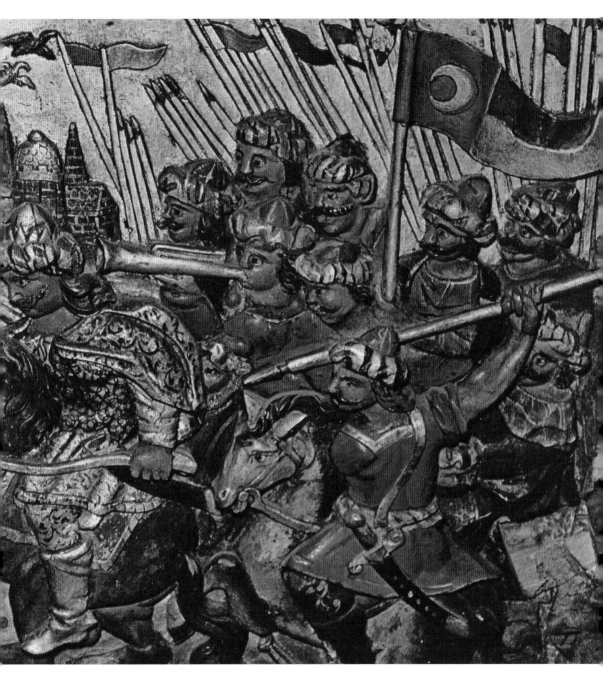

Wood bas-relief on gift carriage Queen Elizabeth to Tzar Boris Godunov

18th-century Defeat with Honor

Turkish Sultan's jewelled gift to Tsar Kremlin Museum 1958

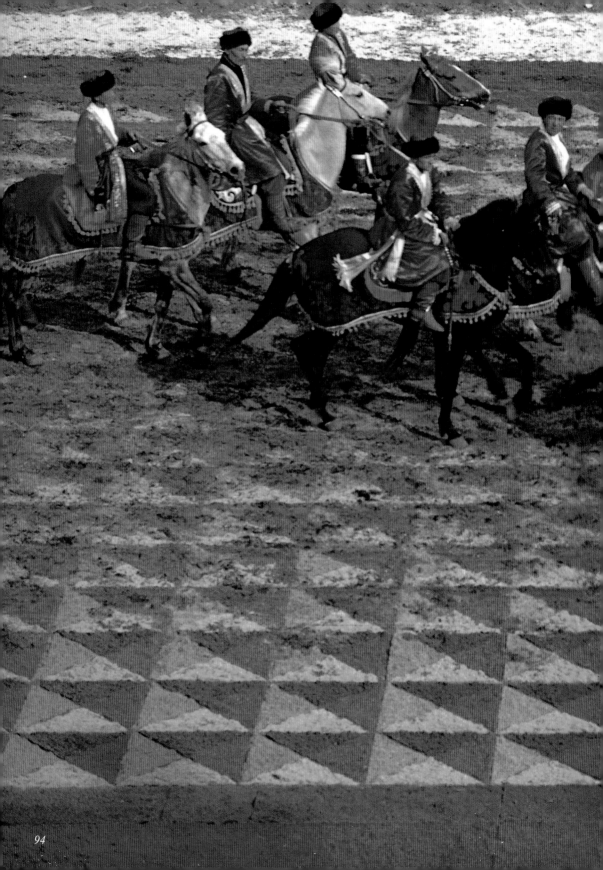

Tadjik tribemen parade on painted sand Moscow May Day 1957

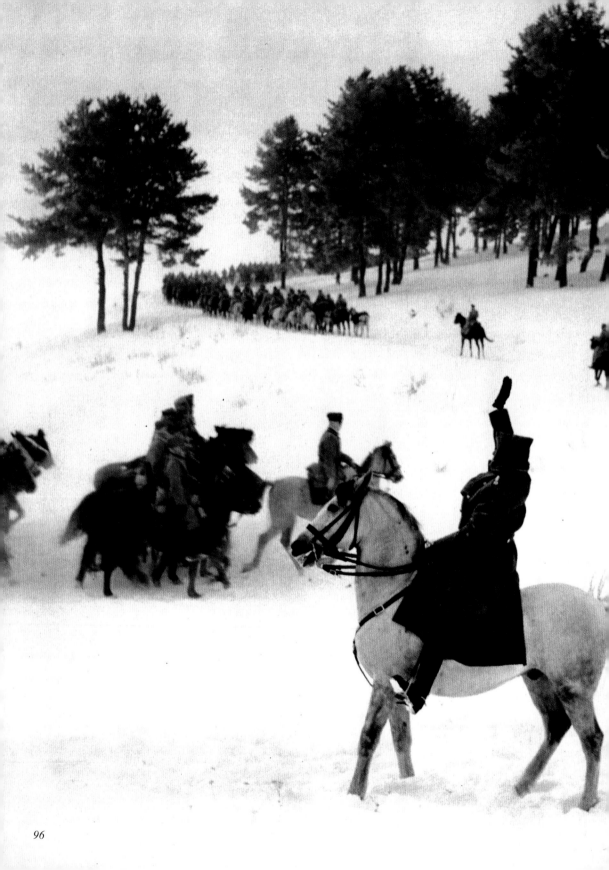

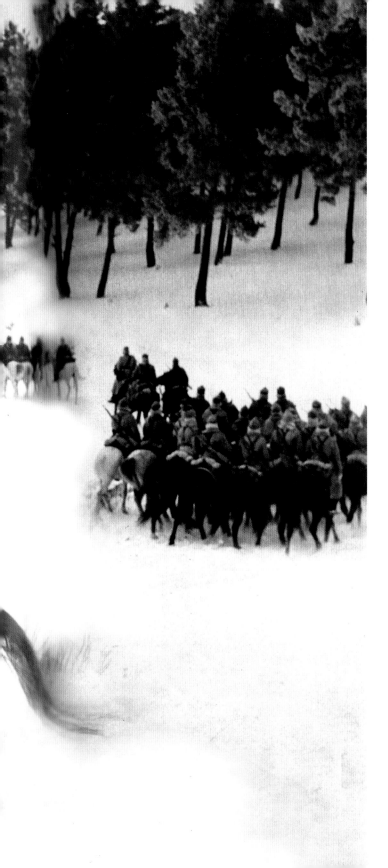

General "Black Avni"
Turkish cavalry division
Russian frontier 1948

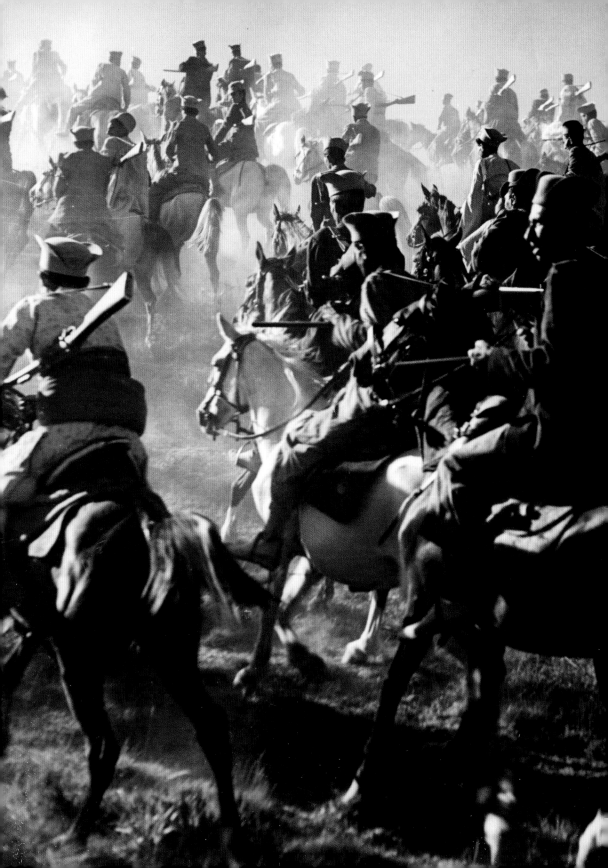

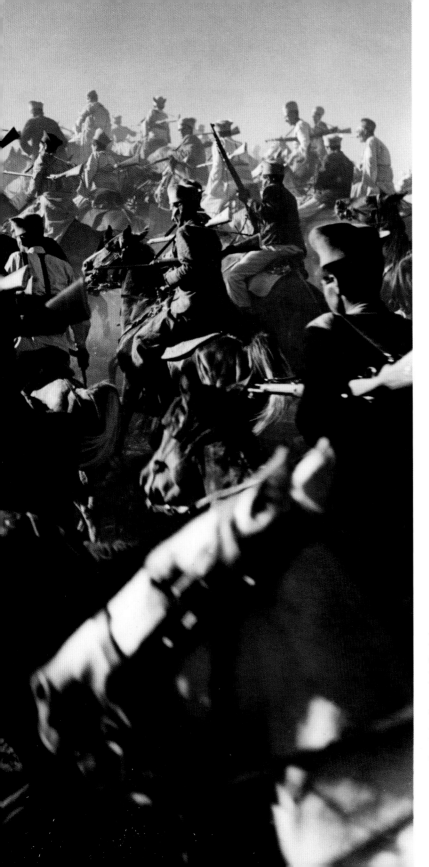

Remote jubilee
of Qashqai nomads
Iran 1946

Today
Nissan Qashqai SUVs
are seen everywhere

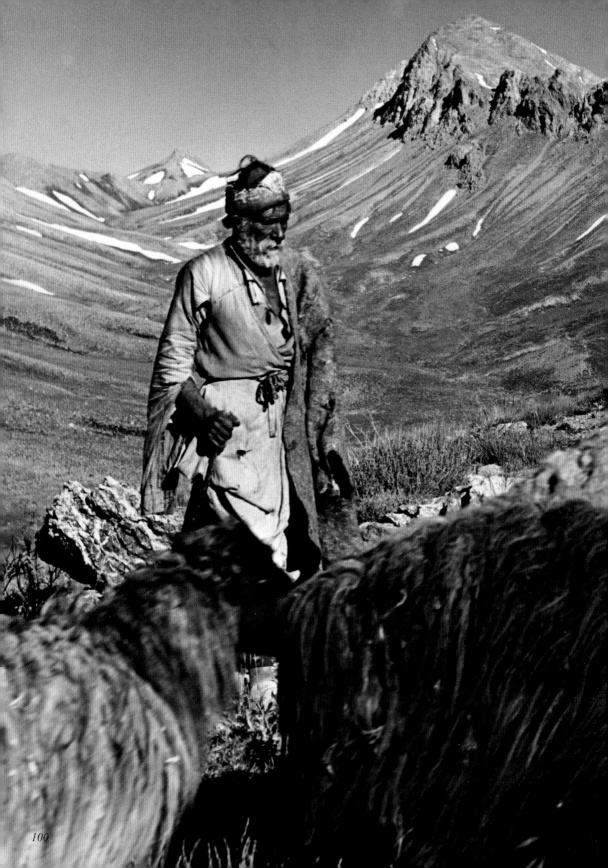

Qashqai nomadic shepherd Iran 1946

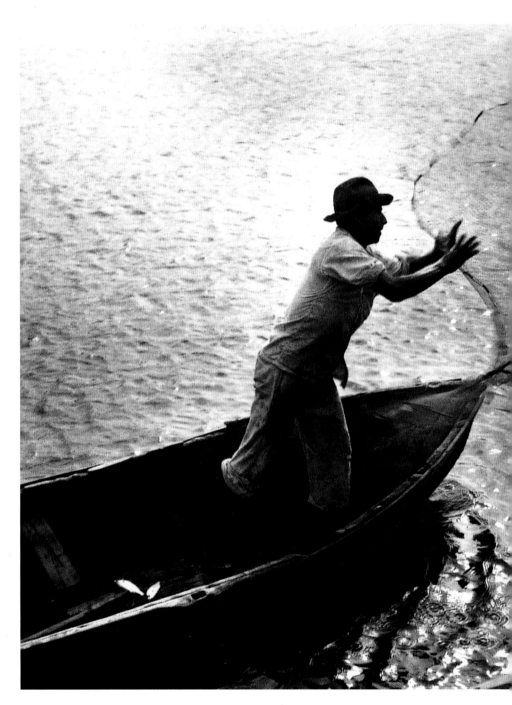

2nd prize National Newspaper Kodak Contest 1937
$250! Dream camera Graflex D 1/1000 shutter
Cooke F2.8 lens launched dream of future

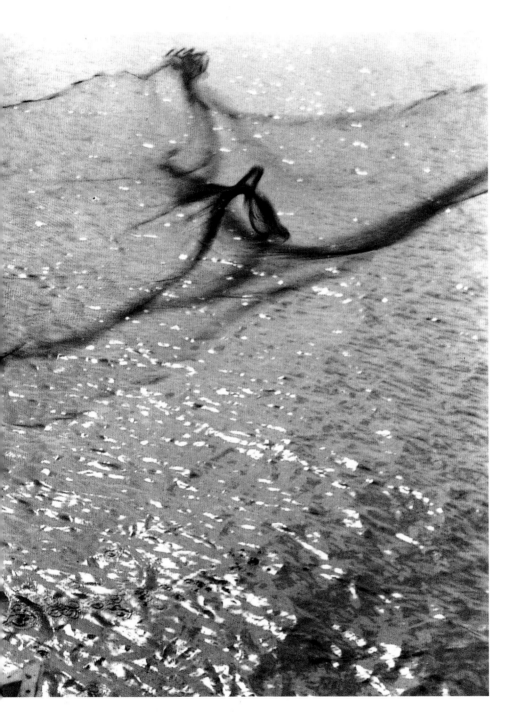

Prize winner Netcaster of Acapulco Mexico 1937
my folding Kodak across street from only hotel in town
with mosquito nets

Source of guano for fertilizer and I was downwind
Lerner American Museum of Natural History Expedition

Cormorant nesting slopes San Lorenzo Islands Peru 1939

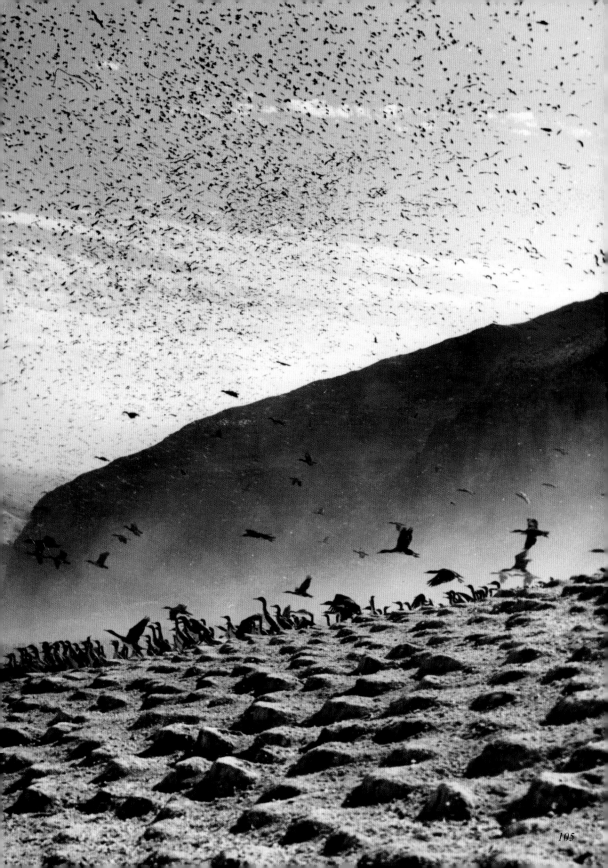

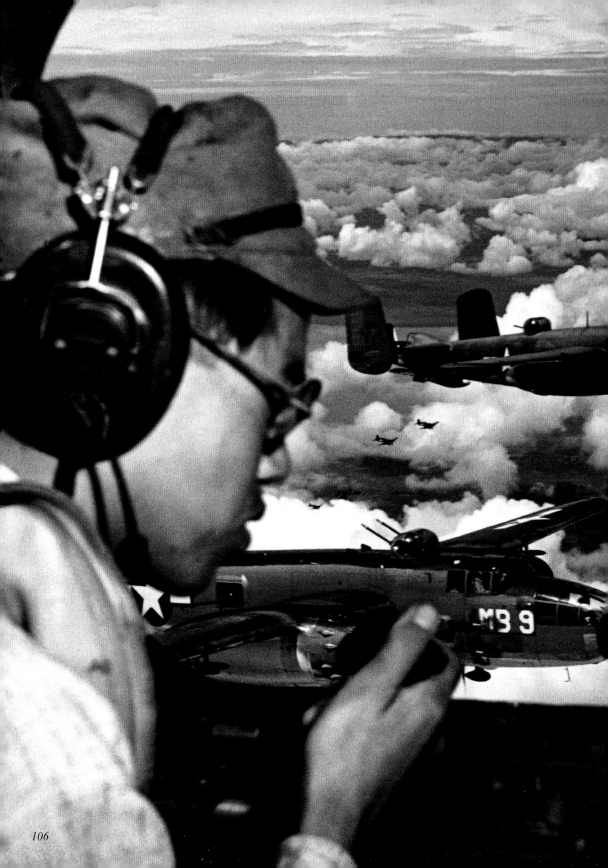

Treason! Japanese officer aiding US Marine bombing and napalm attack
Mindanao Philippine Islands 10th August 1945: Copilot from cockpit
"Russia declared war against Japan"
No bombing/casualties/cost: Hiroshima Nagasaki radioactive

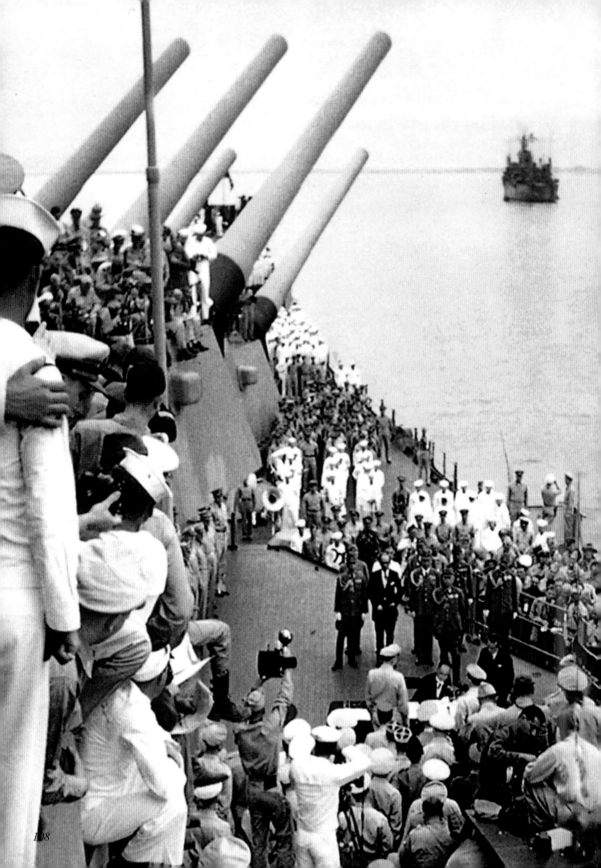

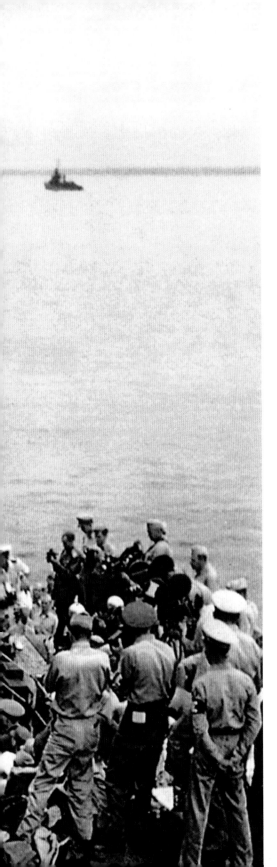

Mr. and Mrs. K.S. Duncan
629 West 57th Street Terrace
Kansas City, Missouri
U.S.A.

Dear Mother and Dad
This is The Day!

Love

Dave

Surrender of Japan
USS Missouri
Tokyo Bay
2 September 1945

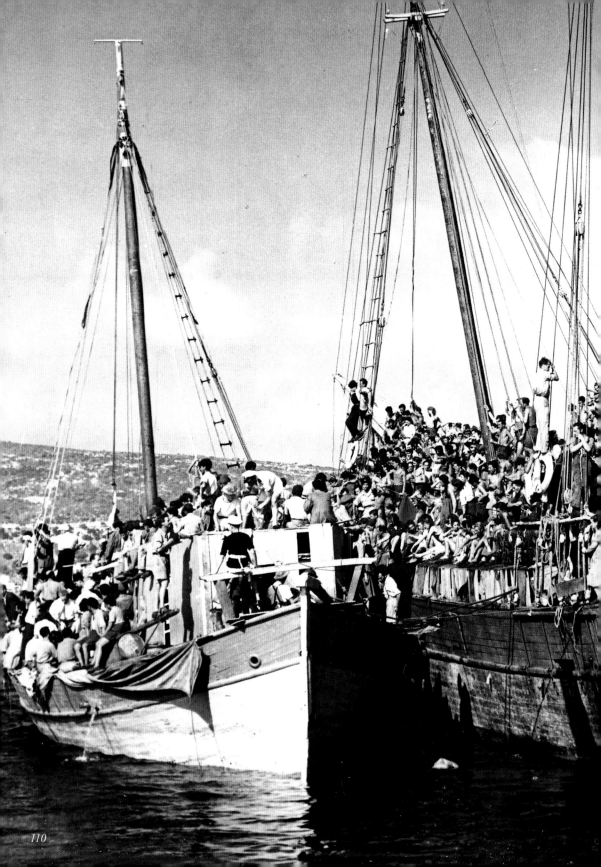

The Holy Land
Jewish refugees and survivors of Holocaust
Haifa Palestine July 1946

Most-sought man
by British Army and
Palestine police agents

Hands of Menachem Begin
"Terrorist Chief"
Irgun Zwei Leumi

Later prime minister

Zionist Dream Map of Israel
their secret headquarters
Tel Aviv Palestine
20 September 1946

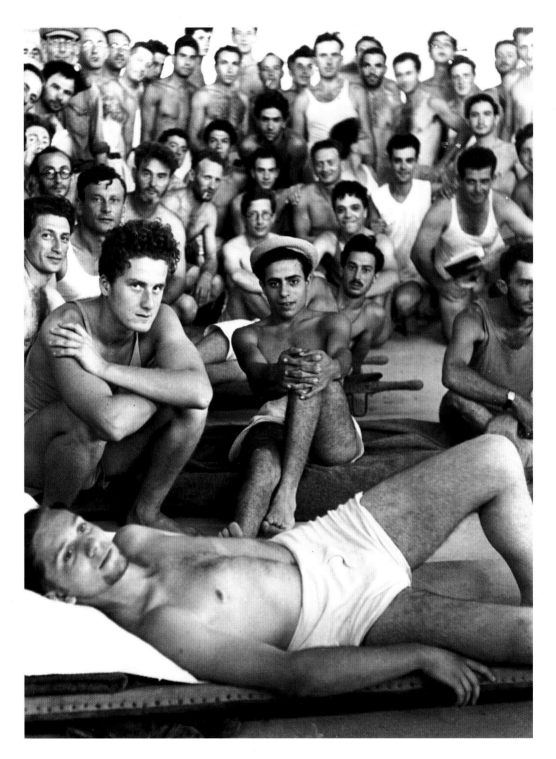

Once again! British "detention" camp Rafat Palestine 1946

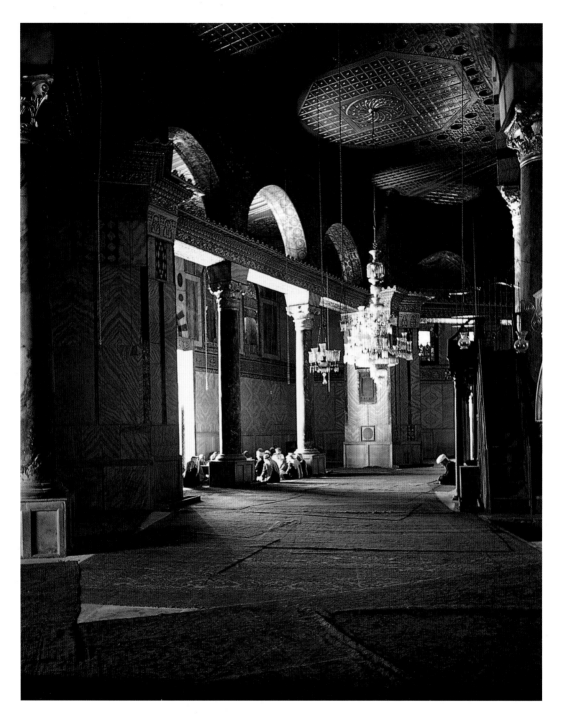

7th-century Dome of the Rock Mosque Jerusalem 1954
Closed one afternoon for its first-ever portrait for LIFE's epic essays
on the dominant religions of our strife-torn widely intolerant even barbaric
theological world seen everywhere today

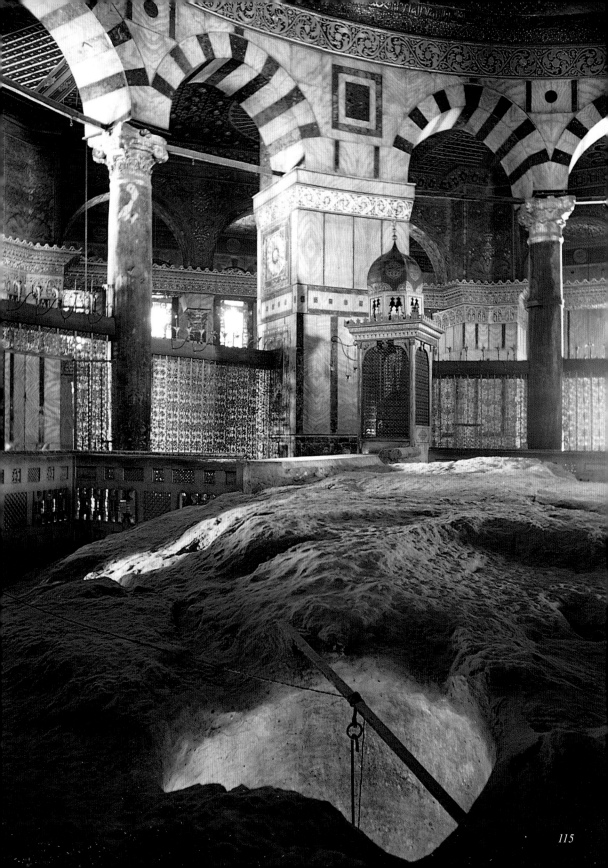

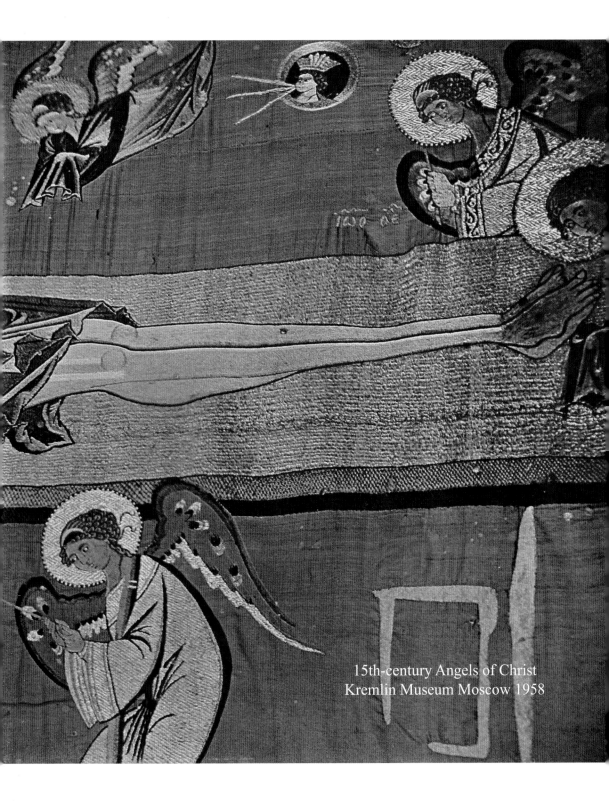

15th-century Angels of Christ
Kremlin Museum Moscow 1958

Palestinian father and son farming near their home

From
Gaza and Ghettos
Dreaming
Fighting and Dying

For This!

East of Bethlehem 1946

End of British Empire
Gandhi and Mountbatten
Last Viceroy of India
New Delhi 1947

Both murdered

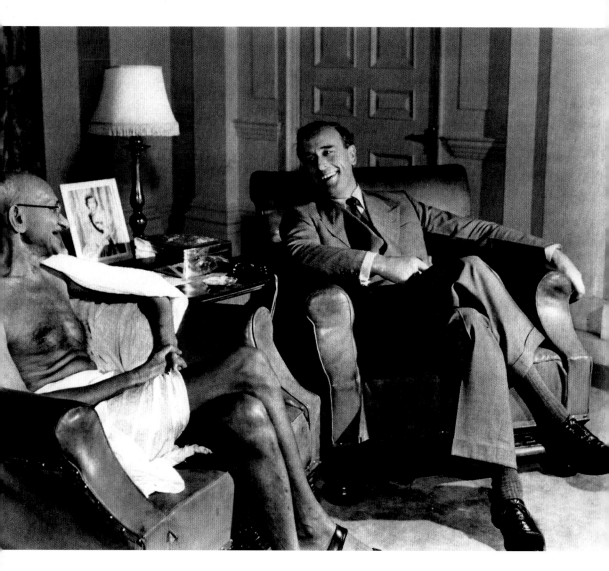

Prayer beads elephant vertebrae necklace
Naked Sadhu at Hardwar on Ganges India 1950
Whispered baritone request
"I'm Bulgarian Dmitri National Guzla Choir
Could you send me two prints?"

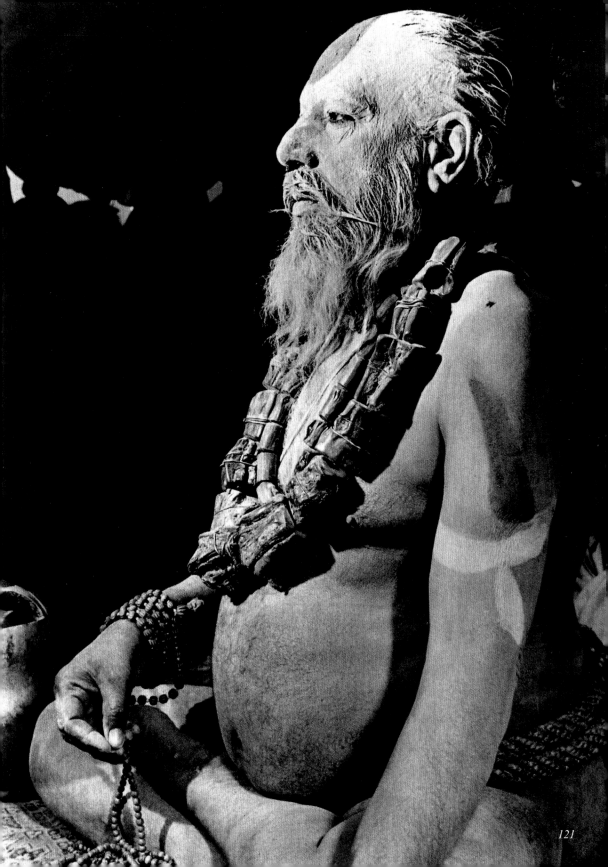

First days of Iron Curtain East-West German border police
Soon snipers landmines machineguns murder
1952

Republican Presidential Convention
Political warfare at home
Miami Beach Florida September 1968

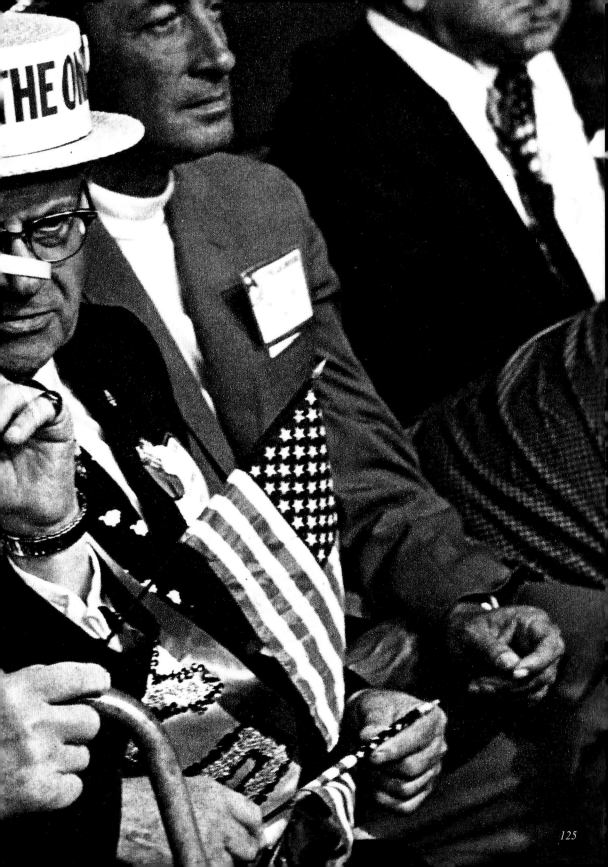

He wrote every word himself

Richard Milhous Nixon
Republican Presidential acceptance speech
Miami Beach Florida September1968

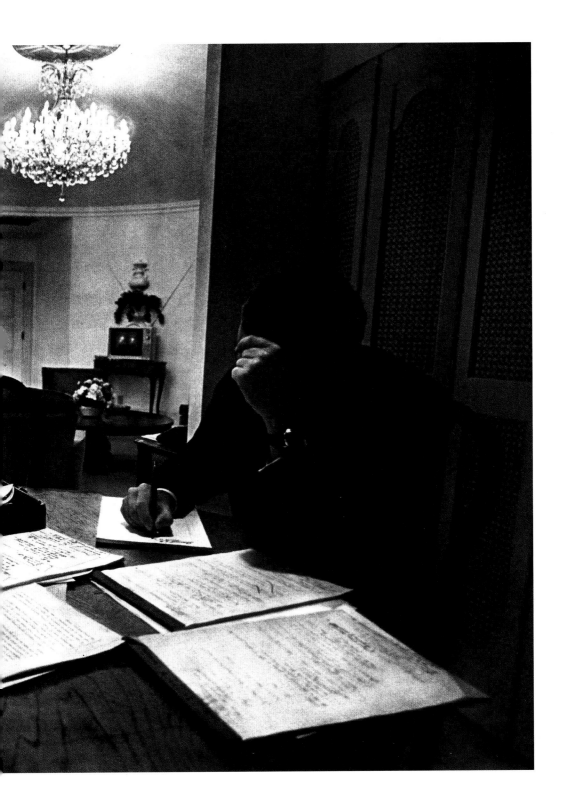

Failed Dreamer

"Together we will soon
climb the highest mountain"

My friend from Bougainville

Nominated for President

The United States of America
Miami Beach 1968

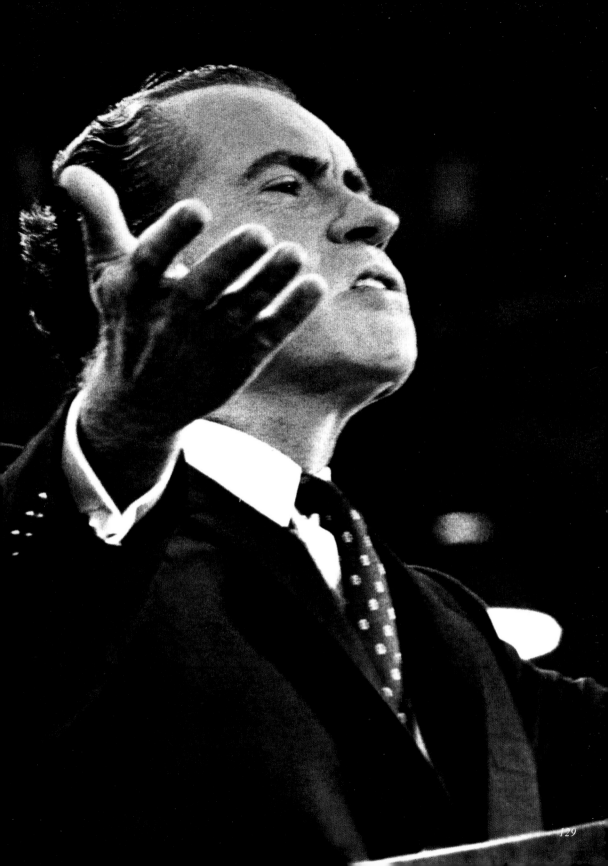

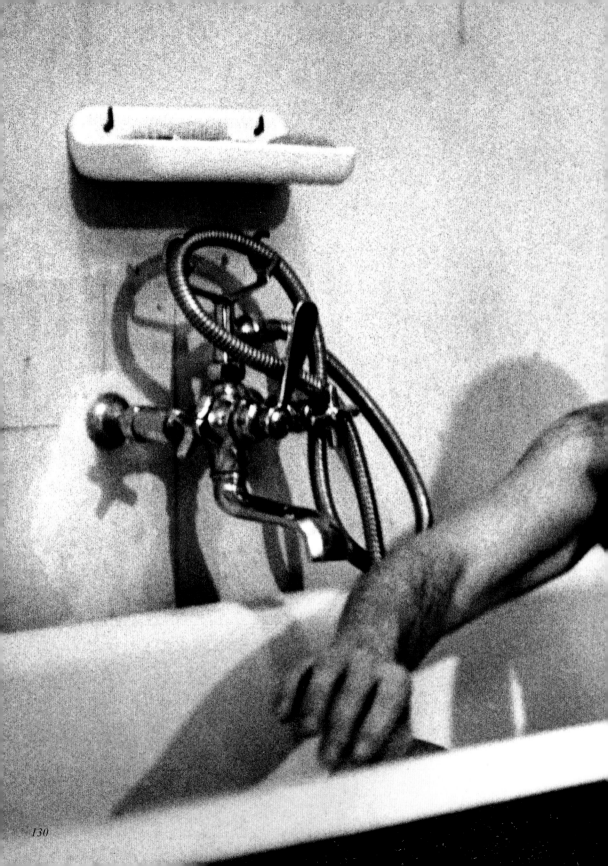

Pablo Picasso
Villa La Californie Cannes France
8 February 1956
My first photograph of soon thousands

"Watch the little bird!" His first gift for me, for my birthday, *was the little bird itself!*
Two years later: "Take it home." He had just leaned a portrait of Jaqueline against the back door of Villa
Californie in the late afternoon sunlight for his signature and inscription *"Para mi amigo Duncan"* to dry.
Then he waved to it — Goodbye!

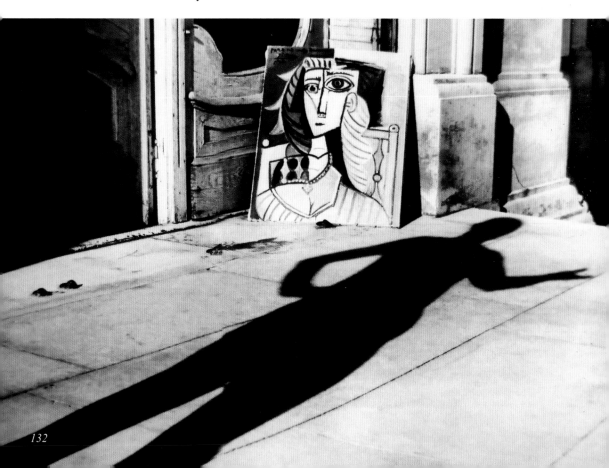

Missouri-to-Mougins! After nearly a century of circling the earth as a photographer, now backflashing while being repaired after a minor accident at home, almost within sniper range from where I had crashed with Duzi and Picasso's now-silent studio over the hill outside my window. I awaited results rolling out of a machine printing shots taken in this new-camera century.

Belgian-born Jef Regnier of Mougins, the village down the road from my serene hip-repair clinic, owned the hi-tech shop printing work from everywhere, including mine. He brought stacks of prints every Friday and spread them across my bed where I could edit mental layouts for a mini-autobiography of life for a month in my one-room world.

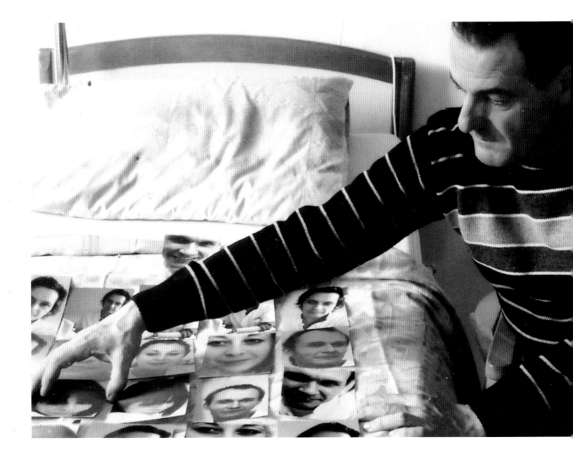

Friends at the Harry Ransom Center faxed a greeting while we were heading home from those four walls at Clinic St. Basile now empty of Marines, Picasso and my memory world.

Duzi was waiting at the top of our front steps — not moving until I got to him.

I heard soft whispers barking somewhere deep in his furry little chest.

He waited for me to tap-tap-tap into the house.

Sat beside me after I made it to a chair — unblinking just watching me.

"I will always be your other crutch."

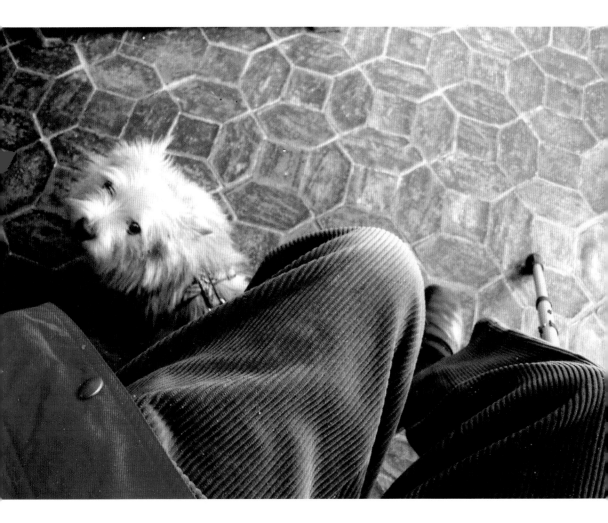

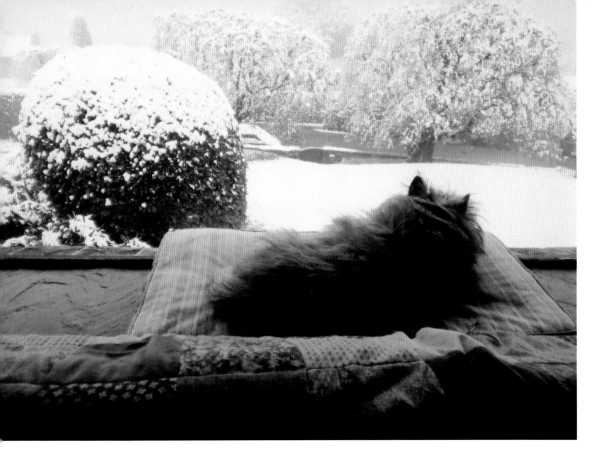

Home!

Celebration!

Snow on the French Riviera with Duzi waiting for his world to reappear.

Olive trees on a hilltop near Grasse with the horizon stretching 20 miles to Nice Airport
and planes lifting off for everywhere; then for another 100 miles across
the glistening Mediterranean to thunderhead clouds over Corsica,
when the fast-melting snow was gone.

His eyes never strayed in search of a favorite toy.

Sheila was reading in the chair where a month earlier he had feigned sleeping while waiting
for me to carry him to his sheepskin-cushioned bed.

When I tripped on a lamp cord at midnight and crashed on the tiled floor Duzi was unhurt, still snuggling
against my chest.

The next morning off to Clinic St. Basile for repairs; every night memories of my world as a photographer.

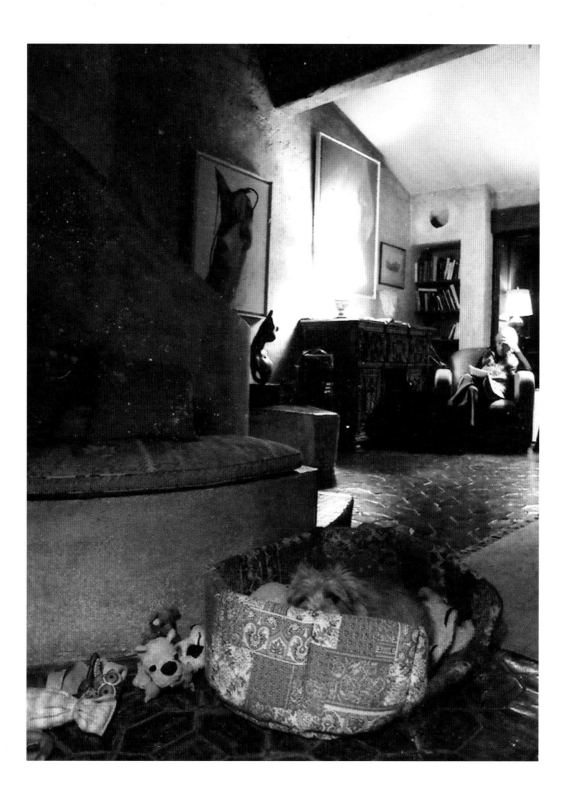

98th birthday visitors

Friends arrived from Wetzlar,
Germany, birthplace of Leicas.
They had the latest future-loaded
dream in hand ready to fire.

Lars Netopil veteran historian
of Leica cameras since 1923 birth
and David Pitzer lawyer with book
designing expertize and sensitive eye
who took a monochrome digital
shot of me with almost no light.

Duzi's grumbling grew ever
louder prodding us to drop
digitals and pixels and hurry to
the table for Sheila's already
neglected and cooling dinner.

23 January 2014
Castellaras le Vieux
France

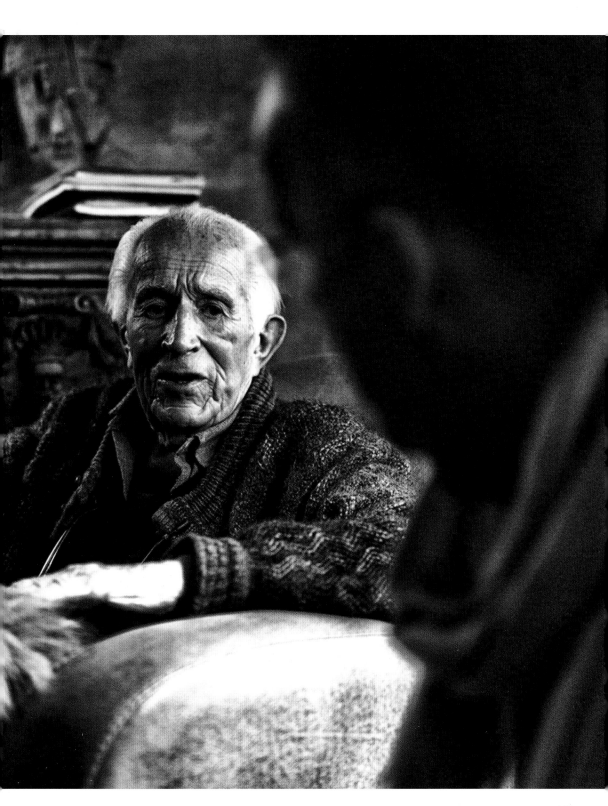

1966

1968

1969

1971

1972

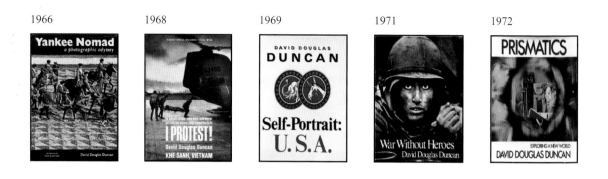

1951

1958

1960

1961

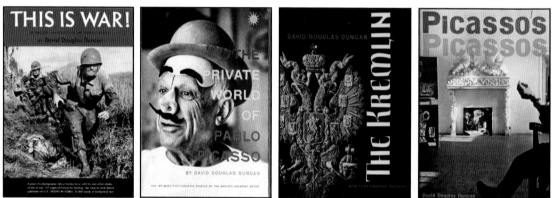

1982

1984

1986

1988

1992

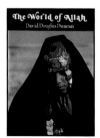
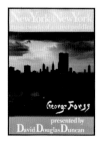